LEGENDARY LOCALS

— OF —

PORTSMOUTH

NEW HAMPSHIRE

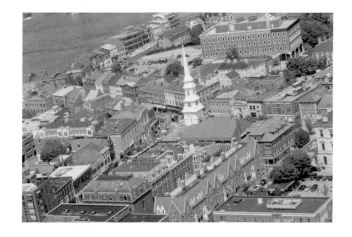

Market Square

Since the mid-1700s, Market Square has been the economic and commercial center of Portsmouth. Throughout the centuries, it has not only served as a military training ground but has also been the site of a meetinghouse and the home of New Hampshire's Colonial legislature. In 1762, it became the first area in the city to be paved, paid for by public lottery. Today, it is the center of life for what has become a vibrant and burgeoning downtown. (Courtesy of the *Portsmouth Herald*.)

Page 1: Downtown Portsmouth

Today, the densely built downtown retains many of the classic brick buildings from the early 1800s. It is home to many of the landmark local businesses in Portsmouth and has served as the hub of arts and culture. (Courtesy of the *Portsmouth Herald*.)

LEGENDARY LOCALS

OF

PORTSMOUTH
NEW HAMPSHIRE

CHARLES McMAHON

LEGENDARY
LOCALS

Legendary Locals is an imprint of Arcadia Publishing
Charleston, South Carolina

Printed in the United States of America

Library of Congress Control Number: 2012955697

For all general information, please contact Arcadia Publishing:
Telephone 843-853-2070
Fax 843-853-0044
E-mail sales@arcadiapublishing.com
For customer service and orders:
Toll-Free 1-888-313-2665

Visit us on the Internet at www.arcadiapublishing.com

Dedication
To the people of Portsmouth—without you, this city would not be what it is today

On the Front Cover: Clockwise from top left:
Frank Jones, brewer and politician, and Justin Hanscom, Jones's confidante, (Courtesy of Portsmouth Athenaeum, see page 18); Sarah Fox, beloved firefighter (Courtesy of the *Portsmouth Herald*, see page 118); Arthur Hilson, pastor, (Courtesy of the *Portsmouth Herald*, see page 74); Joe Shanley, realtor (Courtesy of the *Portsmouth Herald*, see page 64).

On the Back Cover: From left to right:
Eileen Foley, former mayor (Courtesy of the *Portsmouth Herald*, see page 10); Portsmouth High School baseball team, 2011 championship team (Courtesy of the *Portsmouth Herald*, see page 65).

CONTENTS

ACKNOWLEDGMENTS

I would like to gratefully acknowledge the work of all prior historians of Portsmouth, New Hampshire, whose efforts and research serve as the foundation for this volume.

Thank you to Portsmouth Athenaeum and Portsmouth Historical Society for allowing me to share the many photographs of this great community. Special thanks go to Carolyn Marvin, assistant librarian at Portsmouth Athenaeum, and Maryellen Burke, executive director of Portsmouth Historical Society.

I thank John Tabor and the management of Seacoast Media Group for granting permission to publish the many incredible photographs depicting the people of Portsmouth.

To my family, friends, and, of course, Emily, thank you for your love and support.

Finally, my immeasurable gratitude goes to Deb Cram, Rich Beauchesne, Ioanna Raptis, and the many other talented Seacoast Media Group photographers for capturing the many legendary locals of this community throughout the years.

Unless otherwise noted, all images appear courtesy of the *Portsmouth Herald*.

INTRODUCTION

In 1623, a group of English colonists settled along the west banks of what today is known as the Piscataqua River. Settlers are believed to have selected the rich, riverfront landscape because of its close proximity to the Atlantic Ocean, not to mention the many wild strawberry fields growing in the area.

In 1630, the land appropriately came to be known as Strawbery Banke. The town was incorporated in 1653 when it was named Portsmouth in honor of John Mason, the colony's founder. From there on, the city grew into its identity and became the center for trade and commerce for the region. It also served as the capital of Colonial New Hampshire from 1679 until around the middle of the Revolutionary War.

Throughout the 18th century, Portsmouth gradually evolved, going through the growing pains of the industrial revolution. By the turn of the 20th century, the town's historical character and architecture helped it become a tourist destination. Portsmouth was incorporated as a city in 1849. Now, nearly 400 years after it was settled, it consists of roughly 21,000 people and is considered a hub of arts, culture, and tourism. The historical past and cultural strengths of Portsmouth regularly land it on various lists as one of the "best places to live."

Today, the city has more restaurant seats than actual people living there and is among a handful of communities in the country that weathered a recession in the early 2000s and came out stronger as a result. The downtown, although still rife with historical character, has changed dramatically, and development has gradually changed the city over the years. Classic buildings, like the Moffat-Ladd House, coexist with large hotel development and residential condominiums.

The area that was once the waterfront called Puddle Dock is today the site of Strawbery Banke Museum, a living-history attraction that allows visitors to see what Portsmouth was once like.

These days, it is not uncommon to see many of the people mentioned in this book walking through Market Square or dining at one of the hundreds of restaurants located within city limits.

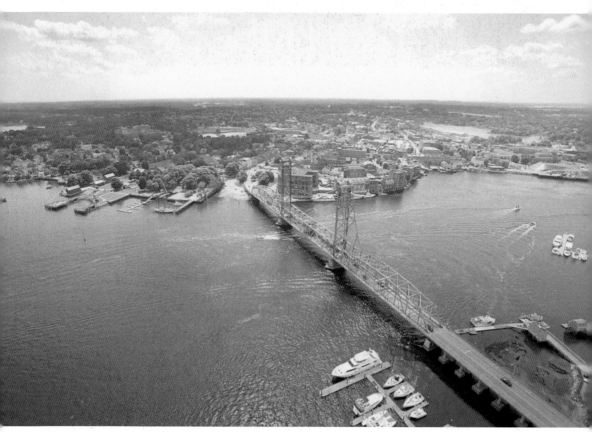

The Port City

The Piscataqua River has undoubtedly served as an artery for Portsmouth throughout its history, helping the city earn a reputation as a historic seaport destination. The river, which has one of the fastest tidal currents in North America, serves as the boundary between Maine and New Hampshire.

CHAPTER ONE

Elected and Respected

Throughout its history, the city of Portsmouth has produced some of the most influential and respected people in New Hampshire. Some of the community leaders have gone on to hold major elected positions within the state and the nation. Others have made a difference through local posts on the city council, planning board, or school board.

No matter the level of their positions, the many elected and respected locals of Portsmouth have surely helped shape the community into what has become a mecca of political stalwarts and persuasive patriarchs.

This chapter will examine not only the people who made a difference but also the organizations that served as agents of change in the community. Readers will find stories about Tobias Lear, who was born and raised in Portsmouth and became best known as Pres. George Washington's private secretary, and Frank Jones, a successful businessman and legendary brewer who served as the mayor of Portsmouth and was also a US congressman.

Perhaps one of the most respected elected officials in the city has been Eileen Foley, who at the age of five helped cut the ribbon to the Memorial Bridge and then grew up to be the longest-serving mayor in Portsmouth's history. Additionally, this story cannot be told without the likes of John Bohenko, a man who took the reins as city manager in 1997 and helped grow Portsmouth into one of the most financially prosperous communities in the state. Other essential leaders include people like Harold Whitehouse, a native of the South End who grew up to become a leader on the city council and one of the most revered civic watchdogs of his time. Without these elected and respected individuals leaving their mark on the community, Portsmouth surely would not be what it is today.

Eileen Dondero Foley

Born to local royalty in 1918, Eileen Dondero Foley—daughter of Mary Carey Dondero, the city's first female mayor (and one of the first in the country)—is perhaps one of the most legendary locals. Foley is the granddaughter of Italian immigrants and the daughter of the first Italian boy born in Portsmouth. Her grandparents made the transatlantic journey to America in 1883, and her grandfather earned money for his family by selling fruit and vegetables around town from a barrel before opening Dondero's Fruit & Vegetable Store on Congress Street. Foley and her three sisters were raised in a home above the store.

At the age of five, Foley solidified herself in local lore when she joined several state and local dignitaries in cutting the ribbon to Memorial Bridge, a bridge opened in 1923 in honor of the sailors and soldiers of New Hampshire who fought in World War I. In her adult life, she served in the Women's Army Corps during World War II. "This town was just militarized," Foley said. "Everything here was war. Every woman in the city took first aid. It was just everything you did, you did just in case the enemy was here."

In 1948, she married John J. Foley, and they enjoyed 44 years of life together until his passing in 1994. Her political career includes working in national, state, and local arenas, and she enjoyed serving seven terms as the New Hampshire state senator from the 24th District. She held the position of minority leader during one of those terms. Additionally, Foley served an unprecedented 16 years as the city's mayor as well as 12 years on the school board. She also served the city as an ambassador during many trips abroad to Portsmouth's sister cities in countries that include Japan, Ireland, and England.

Just before her 95th birthday on February 27, 2013, Foley accepted an invitation from the New Hampshire Department of Transportation to participate in the ribbon-cutting ceremony for the new Memorial Bridge, almost exactly 90 years after she cut the ribbon for the original Memorial Bridge.

Raimond Bowles

A longtime city resident and public servant, Bowles served 15 years on the school board, 7 years as a member of the New Hampshire House of Representatives, 4 years on the city council, and 6 years as chairman of the Portsmouth Fire Commission. He also served as a US Army paratrooper in World War II. Bowles died on May 14, 2011, at the age of 87. (Courtesy of Mary-Ella Bowles.)

Harold Whitehouse

"No fancy speeches or campaign promises, just honest representation for the benefit of my city."

That was Harold Whitehouse's campaign slogan while running for Portsmouth City Council. Whitehouse, a city native who grew up in the South End, stayed true to that slogan throughout his political career. His resume includes 31 years of public service, including 16 years on the school board and 12 years on the city council.

Evelyn Sirrell

She was known as the "People's Mayor." Sirrell, who served 14 years on the city council, eight of them as mayor, merited the distinction because there was no issue too small for her to consider. It was a title she held dear to her heart and fought to uphold.

It was a title she earned as a child of the Great Depression.

Born on January 27, 1931, in Concord, Sirrell was the youngest of seven children and was named Evelyn like her mother. In 1943, when she was 12 and war broke out, Sirrell's family moved to Eliot, Maine, so her father could work as a welder at the Portsmouth Naval Shipyard.

After the war, her father was laid off and forced to take a job making bakery deliveries. With not enough money for her to go to college, Sirrell went to work full-time for Montgomery Ward. In 1978, she went to work for the city as a parking enforcement attendant and an auxiliary police officer. She and her husband, Dick Sirrell, also owned and operated a television- and radio-repair business. They lived above the shop at the corner of State and Chapel Streets.

Not long after closing the family television business in 1983, Sirrell helped found the Association of Portsmouth Taxpayers (APT). She was elected president of APT for four years.

Around this same time, in 1985, Sirrell left city employment to work as a security guard for Portsmouth Savings Bank, a job she held until 2000.

In 1986, Sirrell won a seat on the city council thanks to the backing of the taxpayers' group she helped form. After a shot stint away from city politics, Sirrell won another seat on the council in 1994. In 1996, she received the second-highest number of votes and became assistant mayor under Eileen Foley.

Shortly after losing her husband of 30 years in January 1997, Sirrell decided to run for reelection, and out of 22 candidates vying for nine council seats, received the most votes and was named mayor by a very slim margin. As mayor, she led several public campaigns, most notably the fight to stave off the closure of the Portsmouth Naval Shipyard. She was nearly 75 when she retired from public office in December 2005, and she died on May 8, 2009, at the age of 78.

Charlie Vaughn

Vaughn, who served 8 years in the state legislature, more than 20 years on the city's school board, and many more on other local boards and committees, was a true stalwart of community service. But in addition to his local service, Vaughn also spent 24 years in the military, including time as a prisoner of war in World War II.

At the end of his military career, Vaughn retired as a lieutenant colonel while stationed at Pease Air Force Base. His life came to a tragic end in 2010 when he died while in hospice care, ending a yearlong battle with cancer of the brain and liver.

Evelyn Marconi

A Portsmouth native, Marconi is a former city councilor and one-time owner of Geno's Chowder & Sandwich Shop, which is named after her late husband, who was a local lobsterman. "I'm a native of Portsmouth, and for anyone who knows me, my love for the city is a foregone conclusion," Marconi said in 2001 during her reelection campaign to the city council. In addition to her time served on the city council over the years, Marconi also worked as a tireless stalwart for the Republican Party throughout Portsmouth and all of New Hampshire. Throughout the years, Marconi would often open the doors to her South End chowder house to various political figures, including presidential candidates, first ladies, senators, congressmen, and governors.

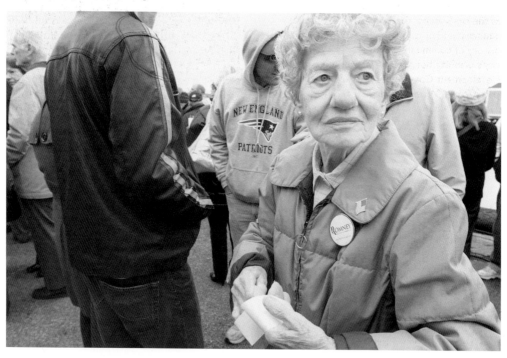

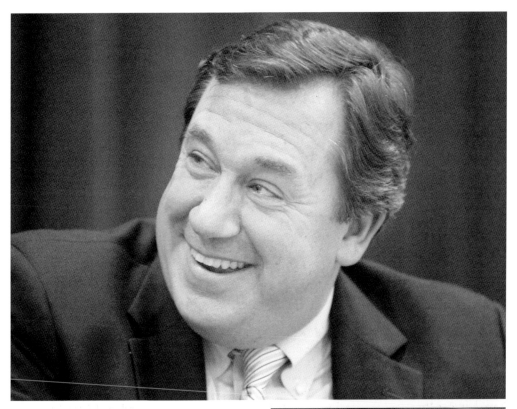

Tom Ferrini

Born in Portsmouth, Ferrini grew up to serve as the city's mayor for two terms and as a city council member for eight years. Ferrini has a long history of community service, serving on the city's planning board, the Portsmouth Economic Development Commission, and many other committees. When he announced he would not run for reelection in 2011, many were left to speculate whether he would seek higher office.

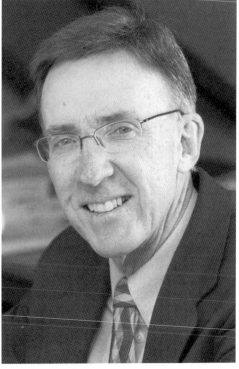

Peter Loughlin

A graduate of St. Patrick School, Loughlin grew up to be the city attorney in the 1970s and a very well respected lawyer throughout the state. In addition to stints on various boards and committees in the community, Loughlin was known as the "Johnny Maple Seed" of Portsmouth, having planted more than 700 trees along the city's streets over the last 30 years.

Ruth Griffin

"My greatest joy in life is in service to others and I live my life following our family motto, 'By courage, not cunning.'" The story of Ruth Lewin Griffin, a former executive councilor for New Hampshire's Third District and longtime stalwart in the Republican Party, exemplifies the idea of public service.

Griffin is most known for her feistiness, her honest counsel, her love for her constituents, and her many decades of public service to Portsmouth, the state legislature, and the executive council. She is also known for the many barnyard animals that have been kept on her family's property since it was built at the corner of Richards Avenue and South Street 120 years ago.

At the local level, Griffin participated on the school board, police commission, and Portsmouth Housing Authority. She served a total of 31 years in elected office.

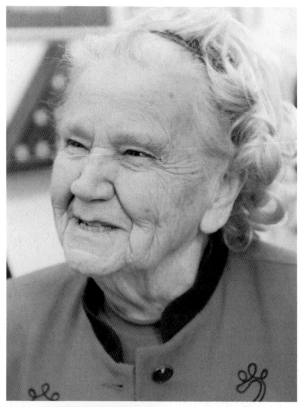

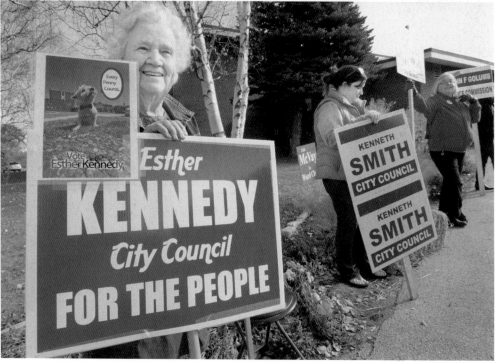

M. Christine Dwyer
Whether it was arts and culture, city governance, economic development, or education, M. Christine Dwyer had her hand in almost everything in Portsmouth. A city councilor, Dwyer was also a driving force in stopping the Music Hall from being destroyed by the wrecking ball in the late 1980s. She also helped initiate Art-Speak, the city's cultural commission.

Martha Fuller Clark
When then senator Barack Obama appointed a team of veteran Democratic activists to oversee his presidential campaign in New Hampshire in 2007, Martha Fuller Clark was at the top of his list. Fuller Clark, who first came to Portsmouth in 1973, served in the New Hampshire House of Representatives for 12 years and went on to become a state senator.

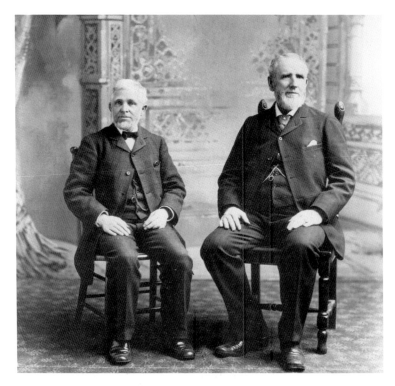

Frank Jones

From a young peddler of pots and pans to the owner of the largest producer of ale in the nation, Frank Jones is revered as one of the most powerful and influential entrepreneurs in US history. Jones was born in Barrington in 1832, but his story does not really begin until his move to Portsmouth at the age of 17. Within a decade of relocating to the Port City, Jones bought out a local brewer and was on his way to becoming the largest producer of ale in the United States.

In addition to employing more than 500 people at his brewery and producing more than 250,000 barrels of ale per year, Jones also built hotels, started water companies, owned the largest shoe factory in the world in the 1880s, and was president of the Boston & Maine Railroad. He also owned the Rockingham Hotel and Wentworth by the Sea, not to mention an additional seven or eight hotels from Boston to as far south as Florida.

In 1868 and 1869, Jones was elected mayor of Portsmouth. He served in Congress from 1875 to 1879 and was also an unsuccessful Democratic candidate for governor of New Hampshire in 1880. In addition to his politics, Jones was also known for the vast amount of land he owned throughout the city. The largest swath owned by Jones involved a 1,000-acre farm on Maplewood Avenue that extended at least from the current intersection of Market Street Extension and Woodbury Avenue all the way to the Interstate 95 rotary and west into part of what is now Pease International Tradeport.

Jones's mammoth brewery dominated the city's West End, before Prohibition shut it down in 1919. Jones, however, sold the company in 1889, though he did remain involved with the brewery until his death. After Prohibition, the brewery reopened under the name Eldridge Brewing Co. The original brewmasters returned to work there and continued to make the popular Frank Jones Ale.

In the 1950s, the brewery and its massive brick structures were shuttered, and some of the buildings eventually burned or were torn down. Jones's large estate on Maplewood Avenue was also divided into small house lots, and his wealth was divided among relatives.

"There has been no one like him before and certainly there is none like him afterwards," well-known historian Richard Adams once said of Jones, who died in Portsmouth in 1902. (Courtesy of Portsmouth Athenaeum.)

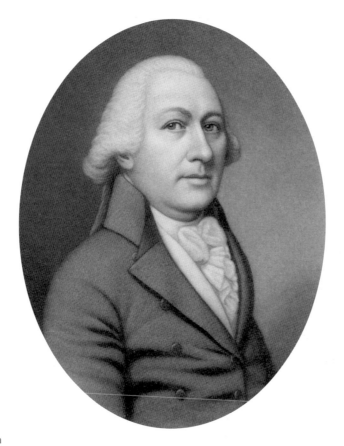

John Langdon

Born in Portsmouth on June 26, 1741, John Langdon went from being a local student to a prominent member of the Continental Congress and a key player in the Revolutionary War.

During his early days, Langdon headed to sea to pursue a mercantile career and amassed great wealth as a local naval merchant. However, the British embargoes preceding the American Revolution inspired Langdon to become a prominent supporter of the Revolutionary movement.

Later, in 1775 and 1776, he would become a member of the Continental Congress. He resigned from that role in June 1776, however, and took a job overseeing the construction of several ships of war for John Paul Jones and led his own companies to battle in Vermont and Rhode Island. He also served several terms as Speaker of the New Hampshire House of Representatives. In 1777, he led an effort to outfit an expedition against the British. During that time, he participated in the Battle of Bennington and commanded a company at Saratoga.

In 1784, Langdon joined the state senate and in 1785 and 1788 was elected president of New Hampshire. In 1787, he again became a member of the Continental Congress. In 1789, he was elected the first president pro tempore of the Senate. That year, George Washington visited Langdon's impressive home at 143 Pleasant Street and wrote in his diary that, of all the homes in Portsmouth, "Gov. Langdon's may be esteemed the first." A few hundred years later, the house remained open to the public to tour and soak in Langdon's legacy.

Langdon also served as president pro tempore of the Senate during the Second Congress. In 1801, he declined to accept the job of secretary of the Navy in the cabinet of Pres. Thomas Jefferson. In his later years, he served the Granite State as a member of the state legislature from 1801 to 1805—the last two terms as Speaker. From 1805 to 1811 (with the exception of 1809), he served as governor of New Hampshire. Langdon died right where he was born, in Portsmouth, on September 18, 1819. His grave can be found in the Langdon tomb in the North Cemetery. (Courtesy of SeacoastNH.com.)

John Bohenko

After taking the reins as city manager in 1997, John Bohenko helped grow the city into a prosperous community, one that to this day is rife with economic development, tourism, arts, and culture. As chief executive and administrative officer of Portsmouth, Bohenko virtually transformed the city into a popular destination to live and visit. In 2010, he was named the most influential person in the Seacoast of New Hampshire.

John Lyons

Portsmouth native John Lyons was a driving force in education at both the local and state levels. Lyons, a former longtime member of the Portsmouth School Board, served as chairman of the New Hampshire State Board of Education from 2007 to 2012. He also served as president of the Portsmouth Rotary Club and owner of Lyons Law Offices.

Terie Norelli

From her residence in Portsmouth, Norelli helped steer the state. Elected to the New Hampshire House of Representatives in 1996, Norelli became the Democratic Speaker of the House from 2006 to 2010. From 2010 to 2012, she served as the minority leader during a tumultuous two years of House leadership by Republicans. In 2012, however, Norelli retained her seat as Speaker.

Laura Pantelakos

Pantelakos spent her life serving both the people of Portsmouth and the Granite State.

She served in the state legislature for 34 years, a tenure that earned her the title of longest-serving member of the New Hampshire House of Representatives. Pantelakos also served a decade on the Portsmouth City Council.

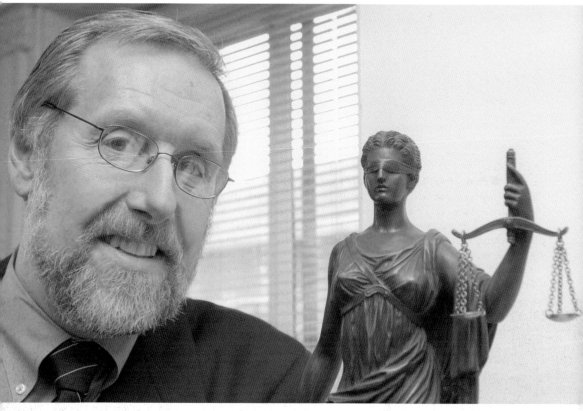

Charles Doleac

A well-known attorney and civic leader, Charles Doleac is most known for his significant contributions to promoting friendly relations between Japan and the United States. After establishing the Japan-America Society of New Hampshire in 1988, Doleac went on to organize the Portsmouth Peace Treaty Forum, which looked at the historical background of the Treaty of Portsmouth, the Russo-Japanese War, and current Japan-Russia relations.

As part of the 100th anniversary of the Portsmouth Peace Treaty in 2005, Doleac organized a community committee that produced a series of significant events that encouraged the deeper understanding of the Japan-United States alliance. In 2011, the Japanese government announced him as a recipient of the Imperial Order of the Rising Sun, Gold Rays with Rosette, an award made twice a year to fewer than 100 foreign nationals who foster positive relationships with Japan.

Jim Splaine

He was the driving force behind marriage equality in New Hampshire. In 2007, Jim Splaine led efforts to allow civil unions in the state, and he was later part of the legislative effort that legalized gay marriage in 2009. Splaine made his presence felt in New Hampshire much before that though.

In 1975, he authored a law that solidified New Hampshire's lead role in the presidential primaries, a position those in the state have fought for years to maintain. In total, Splaine spent 31 years in the state legislature, serving in both the House of Representatives and the senate. He also spent 12 years on the Portsmouth City Council, part of which he spent serving as assistant mayor.

Even after dropping out of politics in 2010, Splaine stayed vocal in the fight for marriage equality.

Robert Shaines

He earned the right to lead Portsmouth by the flip of a coin. In 1960, Shaines became the city's mayor after a vote between him and John Wholey was split. In an effort to settle the tie, the two went to the city manager's office and flipped a coin to see who would be mayor and assistant mayor. After serving for one term, Shaines went on to become a prominent lawyer and author.

Sean Mahoney

A longtime Seacoast businessman, Mahoney was one of many locals who attempted to make themselves known in the political world. He was a former Republican National Committee member who led an unsuccessful campaign as Republican candidate for US Congress in 2010.

Mahoney owned *Business NH Magazine*, New Hampshire's first statewide monthly business publication, from 2003 to 2011.

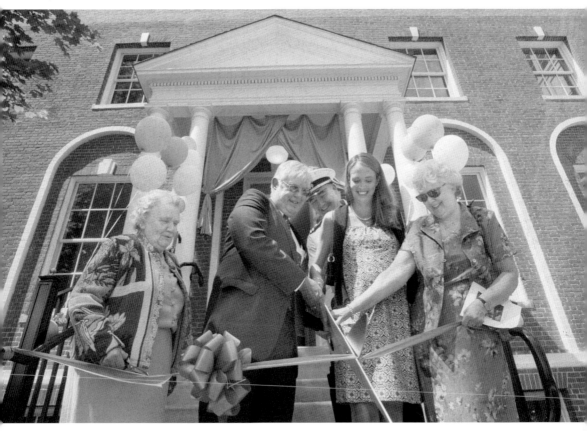

Ted Connors

Connors, a Portsmouth native, was a champion of public housing. Born in the Portsmouth Cottage Hospital on February 8, 1937, he grew up to lead an effort to transform that same hospital into a home for senior housing. The building was renamed Connors Cottage in tribute to the man who ran the Portsmouth Housing Authority for 35 years.

Connors also served as the city's mayor for four years from 1964 to 1967. He was 26 years old when elected and was considered the youngest mayor in the country at the time. He was also the first mayor to be elected by popular vote.

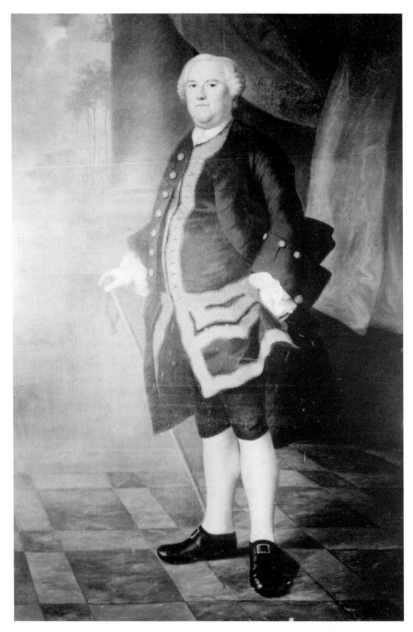

Benning Wentworth

Wentworth was born in Portsmouth on July 24, 1696, to one of the most prominent political and merchant families in the small colony. He was the eldest child of Lt. Gov. John Wentworth.

In 1741, after a career as a merchant, Wentworth was appointed New Hampshire's first royal governor by King George II following New Hampshire's separation from the Massachusetts Bay Colony. He retired from the position in the summer of 1767.

Wentworth's legacy led many to consider him to be one of the richest men in New England during his time, and his home, a rambling, 40-room mansion that overlooks Little Harbor, is considered to be one of the most outstanding homes remaining of the Colonial era. (Courtesy of Portsmouth Historical Society.)

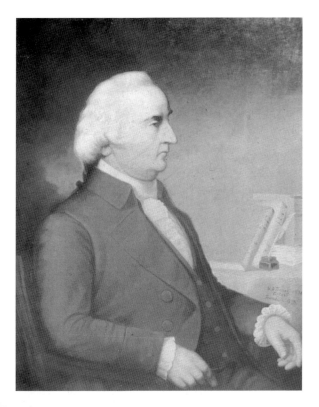

William Whipple

Born across the Piscataqua River in Kittery, Maine, in 1730, Whipple did not make his presence felt in Portsmouth until he landed here in 1759. Upon coming to Portsmouth at the age of 29, Whipple first started out as a merchant but soon after answered the calls to public duty.

In 1775, with his fortune well established, Whipple left business to devote his time to public affairs and was elected to represent Portsmouth at the provincial congress. In the next year, after New Hampshire dissolved the royal government and reorganized with a house of representatives and an executive council, Whipple was made a council member and was promptly elected to the Continental Congress. He served there through 1779.

On July 4, 1776, Whipple penned his signature on the Declaration of Independence, solidifying his place in the history books. Upon arriving home from this historic event, Whipple is said to have planted a horse chestnut tree in the side yard of his home on Market Street. That tree remains there until this day.

During his tenure in state government, Whipple was also involved in many military affairs. In 1777, he was made brigadier general of the New Hampshire Militia. As General Whipple, he led men in the successful expedition at the battles of Stillwater and Saratoga.

Following the war, Whipple continued his career in public service.

During his last years, Whipple held the offices of state legislator from 1780 to 1784 and associate justice of the New Hampshire Superior Court from 1782 to 1785, among many other titles. After battling a heart ailment for several hears, he died in November 1785 at the age of 55 when he reportedly fainted from atop his horse while traveling his court circuit.

He was buried in Union Cemetery. But even after his death, Whipple's wish to help others continued. According to a biography by Dorothy Mansfield Vaughan titled *This Was a Man*, Whipple's wish was to have an autopsy be performed to see what had caused his terrible agony. The autopsy produced evidence suggesting Whipple died as a result of the hardening of the arteries leading to his heart. "And so our William Whipple gave his all to his country, even his heart," read his biography. (Courtesy of Portsmouth Historical Society.)

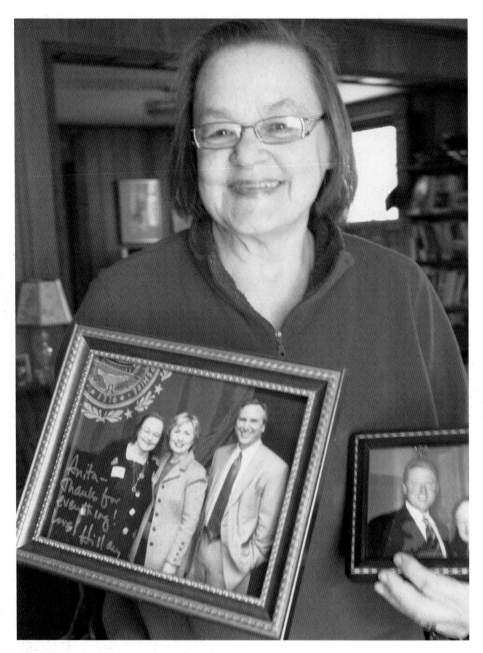

Anita Freedman
Her lifetime was filled with nothing but public service. Anita Freedman was a local veteran Democratic Party activist, and she served as a Democratic National Committeewoman from 1985 to 2008 and as secretary of the New Hampshire Democratic Party from 1985 to 1997.

Freedman was a delegate to the Democratic Party conventions in 1988, 1992, 1996, 2000, 2004 and 2008.

Locally, Freedman served as commissioner of the Portsmouth Housing Authority from 1985 to 2010 and was a member of the Prescott Park Arts Festival Board of Directors. She died at her home on October 9, 2010, at the age of 82. Her body was laid to rest in the Temple Israel Cemetery on Banfield Road.

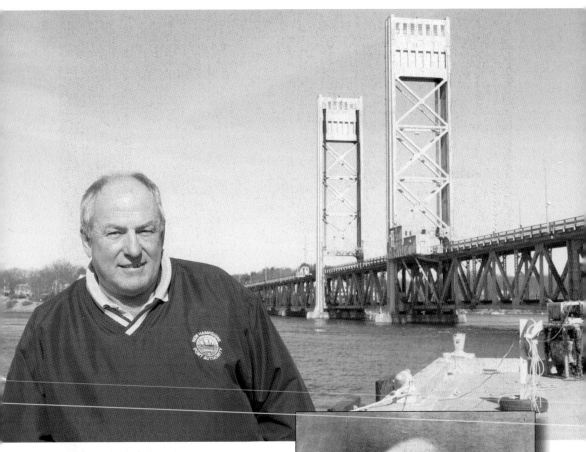

Geno Marconi

As the director of the Port of New Hampshire in Portsmouth, Geno Marconi has served as the gatekeeper for the maritime trade coming up the Piscataqua River over the years. Before he was officially named director in 2002, Marconi spent seven years at the port as operations director. He served the port twice as interim director, first from December 1999 until March 2001, then again from May 2001 until 2002. Marconi is currently the port director in 2013.

Tobias Lear

Lear, who was born and raised in Portsmouth, is best known as Pres. George Washington's private secretary. Born in Portsmouth in 1762, he was raised in a home on Mechanic Street.

Lear served Washington from 1784 until the former president's death in 1799. While employed under Washington, he brought the president to Portsmouth in 1789, amid much fanfare. (Courtesy of Portsmouth Athenaeum.)

Steve Marchand

Marchand served Portsmouth from 2003 to 2005. In 2005, he received the highest number of votes and became mayor of Portsmouth. A champion of government accountability, he worked to reform the city's budget process and helped Portsmouth become a national leader in 21st-century green energy policy, sustainability, and saving taxpayers' money. As mayor, he also fought to save the Portsmouth Naval Shipyard from the Base Realignment and Closure Commission in 2005. He was an early Democratic primary candidate for US Senate in 2008 but dropped out of the race in 2007 to endorse former New Hampshire governor Jeanne Shaheen.

Paul McEachern

A veteran campaigner for the governor's office, McEachern (front, center) ran in 1984, 1986, and 1988. He lost to Chris Spirou in the 1984 Democratic primary, to former Republican governor John Sununu in 1986, and to former governor Judd Gregg in 1988. In 2004, the attorney from Portsmouth lost the Democratic nomination to would-be governor John Lynch. He represented the 16th District in the New Hampshire House of Representatives from 2002 to 2004 and from 2006 to 2010.

Bob Lister
The former superintendent of the city's school system, Lister retired from the post in 2009 and went on to earn a seat on the city council later that year after placing third in his first municipal election. In 2011, Lister was reelected to the council, earning enough votes to become the city's assistant mayor. A resident of Diamond Drive, Lister spent more than 35 years in Portsmouth.

Joanne Dowdell

A Portsmouth resident, Dowdell was widely known as an at-large Democratic National Committee member. In 2012, Dowdell considered running—but ultimately ended up suspending her campaign—for the Democratic nomination in New Hampshire's 1st Congressional District. That same year, Dowdell was named one of the four electors chosen by the state Democratic Party to cast the state's four electoral votes to officially reelect Barack Obama.

Prince Whipple

Not only did he serve with Gen. William Whipple throughout the Revolutionary War, Prince is said to have accompanied Washington when he crossed the Delaware in 1776. After the Revolution, Prince attained his freedom. On Prince's marriage day in 1781, General Whipple prepared a special document that allowed Prince the rights of a freeman. Prince died in Portsmouth in 1797 and is buried near his former master, whose grave is pictured.

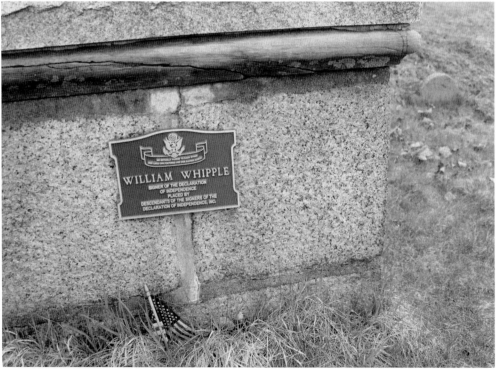

CHAPTER TWO

Buy Local, Eat Local

The many landmark businesses in Portsmouth's history have contributed to making this community a vibrant and prosperous place to live and work. Whether it is the smell of fresh hamburgers made from a lunch cart like Gilley's or the aroma of hot coffee wafting throughout Market Square from the windows of Café Brioche, the many local businesses have certainly earned their place in the city's history books. In this chapter, readers will be led on a tour of some of Portsmouth's most famous food and retail establishments. In includes a look at such legendary eateries as Gilley's PM Lunch and a famed food cart that once sold hot dogs in Market Square and continues that tradition today on Fleet Street. Readers will also get to sample what a slice of pie is like from Savario's, a longtime pizza spot on State Street owned by Frank Catalino.

Readers will learn how the community came together to save RiverRun Bookstore, an independent book seller that was forced to revamp its business model to rely heavily on the community in order to thrive in the challenging economy. A glimpse is also given of the Clip Joint Barbers, an institution in the local hair-cutting industry since 1980.

In addition to the restaurants, barbershops, and bookstores, the history of Portsmouth commerce cannot be told without the story of proprietors like Jill and Ernie Breneman, a couple who in 1978 started a toy store on Market Street, and Jay McSharry, a restaurateur who began working in restaurants at the age of 14 and grew up to be one of the most influential people in the local business community.

Some of the more unconventional businessmen in the city are also included in this chapter, such as Tony Tzortzakis, an independent bike seller on Islington Street who, after operating his store since at least the mid-1990s, was almost forced to close in 2012.

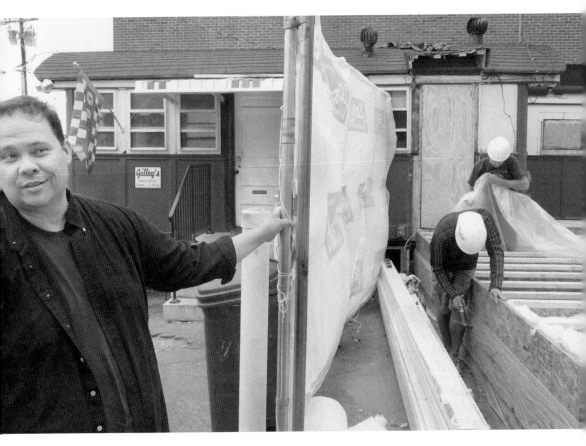

Gilley's PM Lunch

The legendary Gilley's lunch truck has served savory hamburgers and hot dogs to locals and visitors alike since 1912. The famed business was named after longtime employee Ralph "Gilley" Gilbert, who served dogs and burgers from the diner's tiny kitchen for more than five decades. During his time in Portsmouth, Gilley was known for his "flawless memory, kindness, and generosity." Gilley died in 1986, but his legend never went away. "He greeted customers by name, had a good word for everyone, and never let the lack of funds prevent a hungry customer from eating," according to the restaurant's website.

In its early years, the diner could be found in Market Square each evening and parked in front of the North Church. The diner is said to have first been hauled around by horse, then tractor and finally, by truck. Today's lunch cart was built in 1940 by the Worcester Diner Co. of Worcester, Massachusetts. It was one of only five that were ever built.

In June 1974, Gilley's was moved to its current location on Fleet Street. A wing was added to the cart in May 1996, allowing for more storage, an expanded menu, and better service for customers.

A hand-painted mural behind the Fleet Street diner that depicted the business's heyday in Market Square was demolished in 1999. The mural had been painted in the early 1970s by a longtime employee of Gilley's, and it was repainted in 2001.

In the old days, the streets around Gilley's were rough, commonly home to late-night fistfights and skirmishes, not to mention encounters with old friends and curious characters.

In 2010, owner Steve Kennedy decided to expand the lunch cart in an attempt to revitalize the iconic downtown diner. The truck that towed the diner was removed, but the original interior was mostly maintained. Today, Gilley's continues to be one of the few places in downtown Portsmouth where someone can get a late-night hamburger or hot dog.

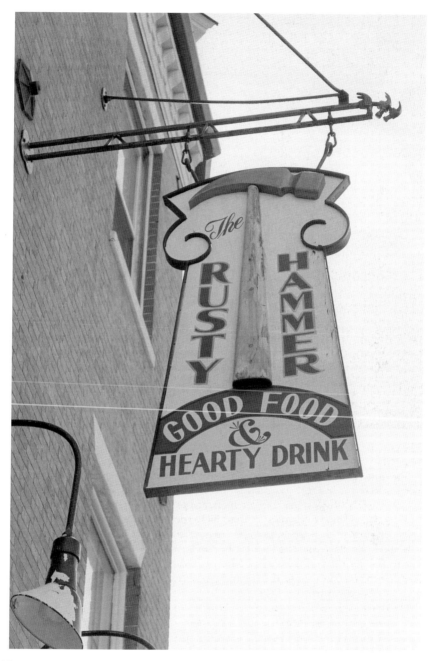

Rusty Hammer

When Rus Hammer opened his restaurant—the Rusty Hammer—in 1978, he served what would be his first of thousands of "wimpy burgers." Since that time, the restaurant located at the corner of State and Pleasant Streets and also known as "the Hammer" has become one of the most popular places in Portsmouth. It underwent an expansion in 1992, which ballooned the original 60-seat restaurant into a 200-seat space for social gatherings and special functions. When asked in 2004 what it took to run a successful business, Hammer and co-owner Bill MacMillian said the secret was "a lot of hours, attention to detail, good employees, a good location, a good plan, and luck."

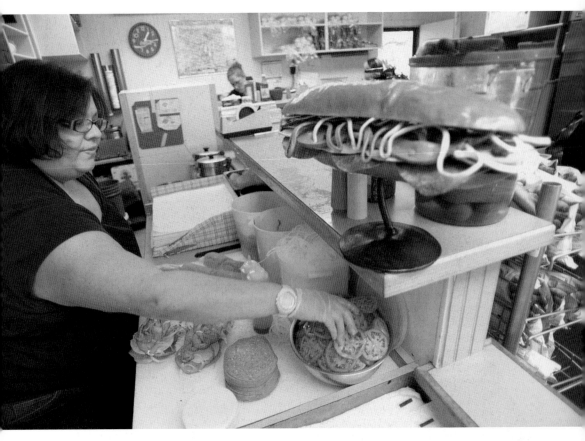

Moe's

The legend of Moe's began in 1959 when Phil "Moe" Pagano bought a sandwich shop on Daniel Street. He would only sell one type of sandwich at his new shop—the Moe's Original sandwich—which was based on a recipe handed down to Pagano from his mother. As time passed, the concept caught on in Portsmouth as patrons became accustomed to the unique flavor of Moe's sandwich.

In 1993, Pagano started selling franchises, offering others a chance to own their own Moe's Italian Sandwich Shop. The sandwich shop's current owner, Cheryl Pagano (pictured), is a part of three generations of Paganos that have helped run the business.

Café Brioche

With its French pastries and Parisian-style outdoor seating in Market Square, Café Brioche came to be a city landmark. Cofounders Paul Norton and David Bowen opened the café in 1984 in a three-story building at the corner of Pleasant and Daniel Streets. A decade later in 1994, the owners decided to expand, nearly doubling the size of this ground-floor café. Norton sold the space in 2001. (Courtesy of Portsmouth Athenaeum.)

Breaking New Grounds

Breaking New Grounds opened at 16 Market Street in July 1993. Owner Matt Govoni made his Market Street coffee shop into a business bursting with popularity. It was so popular, in fact, that it became difficult to capture one of the tiny tables crammed in the back of the café. In 2004, Govoni moved his business to 14 Market Square, the former site of Café Brioche.

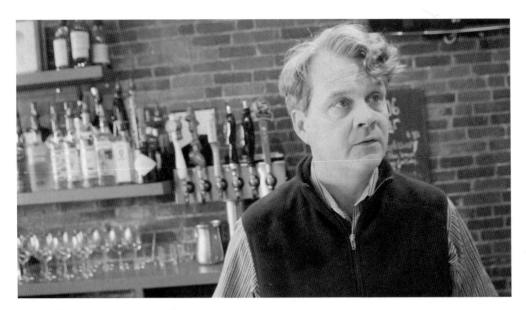

Jay McSharry

McSharry is the definition of "restaurateur." But in addition to his experience in the culinary business, he is also an entrepreneur, humanitarian, and a man who works hard to get Portsmouth noticed. McSharry, who had been working in restaurants since he was 14, opened Jumpin' Jay's Fish Cafe in 1990 with a book about how to run a business and only $80,000 and 20 tables.

Buzzy Hanscom

Samuel "Buzzy" Hanscom was the face of fuel in Portsmouth for decades. Not only is he the owner of a home-heating fuel business on Maplewood Avenue, he also owns twin truck stops on both sides of the Route 1 Bypass. In 2012, Hanscom threw a party at his bypass gas stop to celebrate his 80th birthday and 47 years in business. "I've seen anyone from everywhere and anywhere," he said.

Caffe Killim

The story of how Caffe Kilim came to be begins in the early 1990s, a time when Janice Schenker and Yalcin Yazgan had just sold their home in York, Maine, were out of work, and were looking for something to do. From 1993 to 1996, Schenker and Yazgan found themselves operating the young coffeehouse in a small space at 85 Daniel Street. A few years after first opening, the couple moved the business to 79 Daniel Street. The business flourished in that location from 1996 to 2006. Eventually, the pair found themselves moving to 163 Islington Street, where they have been ever since. In early January 2013, the coffee shop celebrated its 20th anniversary.

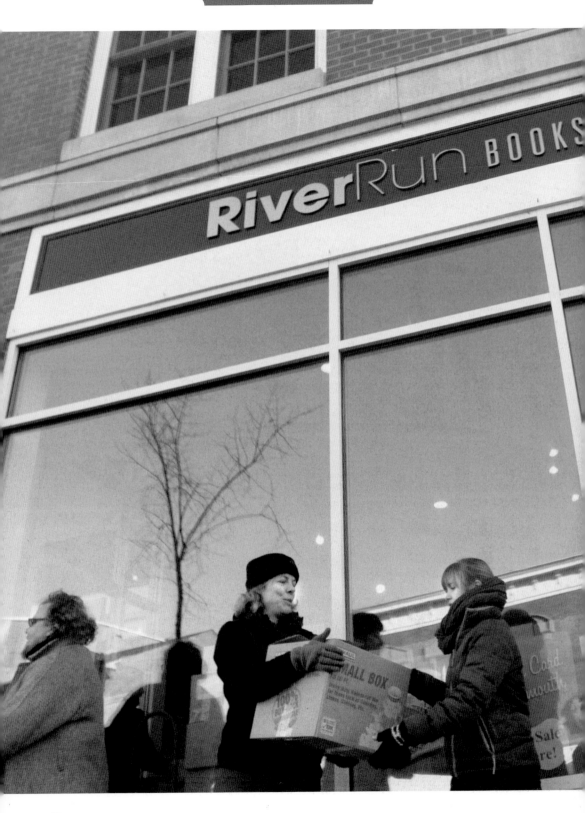

RiverRun Bookstore It started out as a small bookstore on Commercial Alley in 2002 and grew into much, much more. Owned by Tom Holbrook, an avid fiction reader, RiverRun Bookstore moved from Commercial Alley to Congress Street in 2006. On December 29, 2011, more than 150 volunteers showed up at RiverRun Bookstore on Congress Street to help the local book dealer relocate again to a new location on Fleet Street. In danger of closing, Holbrook reached out to the community to help him keep the business afloat, and it worked. This event helped solidify RiverRun as *the* community bookstore in Portsmouth.

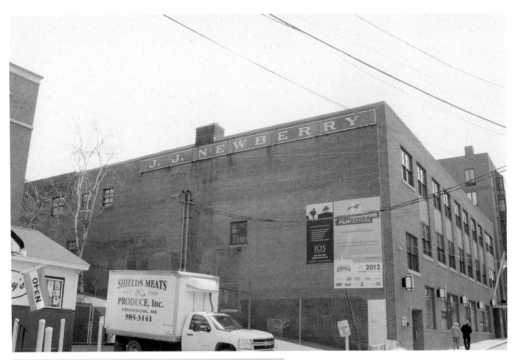

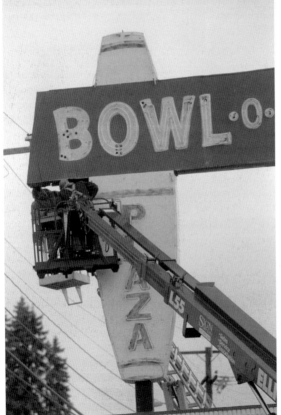

J.J. Newbury

It was a five-and-dime chain store on Congress Street that featured a lunch counter enjoyed by residents for decades. The department store closed in the early 1990s, leaving a gaping hole in downtown Portsmouth. A J.J. Newberry sign still remains on the back of the building that abuts Fleet Street. It is the last, lonely reminder of a once-great chain.

Bowl-O-Rama

In April 2009, Bowl-O-Rama owner Nick Genimitas took down a sign that had stood outside his family's Lafayette Road bowling alley for more than 50 years. Constructed in the 1960s, the 225-square-foot sign stood 33 feet tall and was, for nearly half a century, the largest bowling pin in the Seacoast.

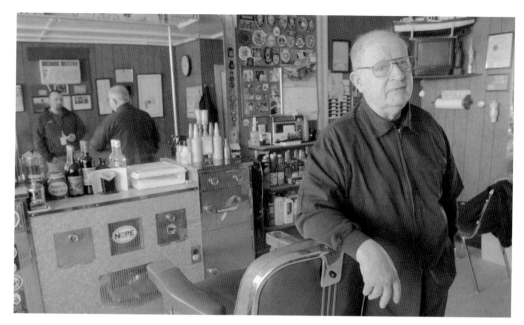

John's Barber Shop

Since 1923, John's Barber Shop has been the quintessential storefront barbershop in Portsmouth. Located on Daniel Street, the shop was first operated by John Russo and was later taken over by the younger Russo, who began cutting men's hair in 1954. In addition to locals, Russo's barber pole attracted several politicians and presidential candidates throughout the years.

G. Willikers

In 1978, Jill and Ernie Breneman opened the doors to their new store—G. Willikers—at 13 Market Street. It was the ideal family-run toy store. All three of the Brenemen children worked at the store on and off during their adolescence, and middle son Bob (pictured) took over the business in 1989. He was joined by his younger sister Jody in 1998.

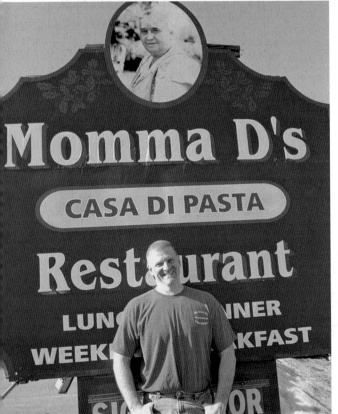

The Clip Joint Barbers
Since 1980, the Clip Joint Barbers has been an institution in the local hair-cutting industry.

Owner Debra Phillips, who died in 2012, first opened the barbershop in 1980 at 414 State Street, where it operated for its first five years. The business moved to 92 Pleasant Street in 1985. In 2013, after Phillips's death, the 10 longtime female barbers helped move the business to Daniel Street. Pictured is longtime employee Sandy Cole.

Momma D's Casa di Pasta
One moment, Henry Dutkowski was graduating from college, and the next, he was on his way to running the family business his stepfather had opened in 1985. That was 1993, and since that time, Dutkowski has worked to keep his family's traditional Italian menu in check. The recipes were handed down from Dutkowski's stepfather's mother, "Momma D," who came to the United States in the 1940s from Portello, Italy.

Savario's

Frank Catalino's love for pizza and people led him to open Savario's in downtown Portsmouth in 1980. Located in a 550-square-foot space on State Street, the pizza shop started with only a handwritten menu, a few appliances, and the support of Catalino's family. During Savario's 20th anniversary in 2010, Catalino said that throughout those two decades he had probably made about 100,000 pizza pies.

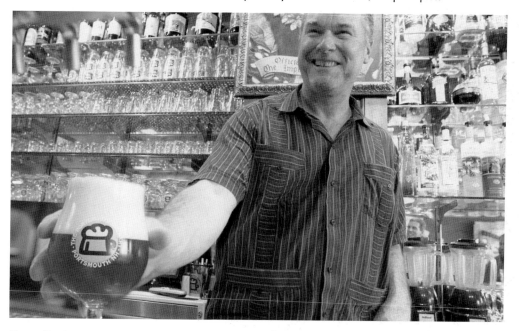

Peter Egelston

In 1991, Egelston and his sister Janet opened the Portsmouth Brewery on Market Street. The brewery was the Granite State's first brewpub. In 1993, Egelston attended the auction of the bankrupt Frank Jones Brewing Company and, although he had not intended to bid on anything that day, walked away with a brewery that would later become known as Smuttynose.

Old Ferry Land

The Old Ferry Landing on Ceres Street, which was once a ferryboat terminal that provided a crucial link between Maine and New Hampshire, was first opened by Richard Blalock in 1975. Today, Portsmouth's oldest waterfront restaurant is a popular seasonal attraction owned by Jack Blalock, who started out working for his father after postponing his plans for graduation and law school. Blalock, who also served as former assistant mayor in Portsmouth, said his decision to take over the family business was the best one he ever made. In 2013, Blalock opened up the Old Ferry Landing for its 39th season along with the help of a loyal staff and family members.

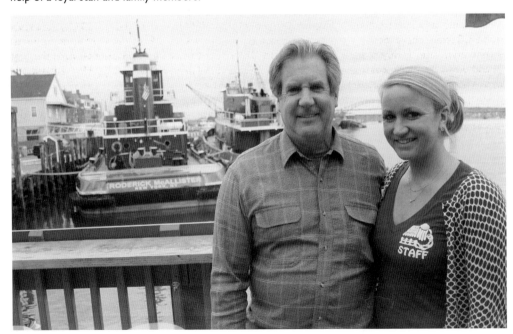

Portsmouth Pilots

The Holt family, whose members have served as state pilots and docking pilots in Portsmouth for three generations, has a long tradition of involvement with Moran. "We go back to the late 1800s," said Dick Holt Sr., a senior ship pilot and captain whose great-grandfather Henry B. Holt also worked on tugboats. A generation after Henry Holt worked the trade, Dick's grandfather Shirley H. Holt Sr. rode the tugs up and down the Maine coast and the Piscataqua River. Dick's father, Shirley Holt Jr., also worked as a tugboat captain and ship pilot, as did Dick's brother Shirley Holt III.

Along with Holt, today, Portsmouth Pilots, Inc., employs both his son Dick Holt Jr. and Shirley's son Chris Holt. Chris's brother Steve Holt also worked the river as the captain of the tugboat the *Eugenia Moran*.

Emilio Maddaloni

Italian American Emilio Maddaloni opened his store, Emilio's, in 1975, and kept it afloat for 30 years. He established his business on Daniel Street because the city at the time needed an imported-food store. After closing in 2005, Emilio said he would miss seeing the people more than owning the business. Today, he remains a common presence in the downtown.

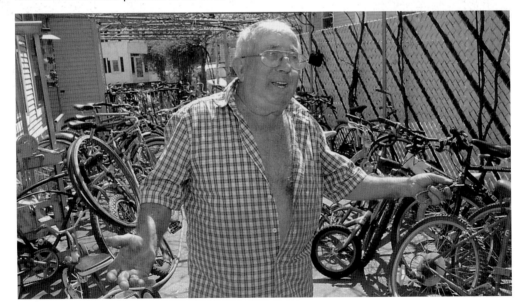

Tony Tzortzakis

Tzortzakis's independent bike business on Islington Street has been in existence since at least the mid-1990s. The longtime city resident, who speaks with a thick Greek accent, is a mainstay in the community, both selling and restoring bicycles from his driveway. In 2012, Tzortzakis's business was nearly closed by the city. It was saved, however, thanks to an outpouring of community support.

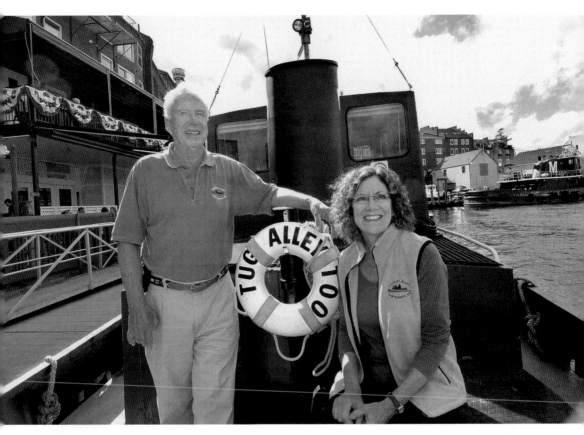

Tugboat Alley

As owners of Tugboat Alley on Bow Street, Bob and Natalie Hassold once owned and operated perhaps one of Portsmouth's most-beloved waterfront landmarks. Bob Hassold purchased *Tug Alley Too*, a 1966, steel-hulled tugboat, in 2001 while vacation in Rockland, Maine, with his wife. Back then, Hassold said, he had no clue how to operate the 13-ton tug with a 10-knot cruising speed.

Nearly 10 years later, he decided to close his successful tugboat tour business. As the captain of the tug, Hassold took more than 8,000 people on tours up and down the Piscataqua River. In 2013, Hassold sold the tugboat after years of searching for the right buyer.

"Cuzin" Richard Smith
"Cuzin" Richard Smith began his work as the face of entertainment in 1976. In addition to running a successful entertainment business, Smith helped cofound the Portsmouth Concert Co-Operative. He also served on the board of Pro Portsmouth and helped it cofound First Night Portsmouth, a popular New Year's Eve event.

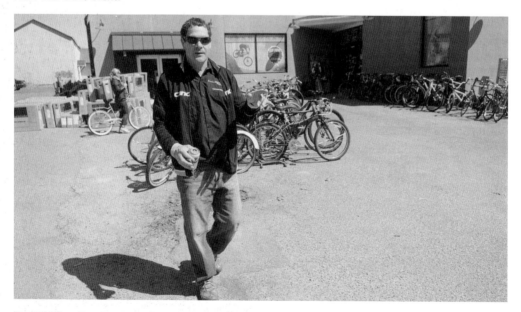

Papa Wheelies
Since opening in 2001, Papa Wheelies owner Dan Houston and his employees have routinely opened up the shop to the community for bike swaps and various bicycle-related events and celebrations. Houston has been one of the strongest advocates for bicycling in the community over the years, growing the business into the Seacoast's largest provider of both new and used bikes.

Dinnerhorn and Bratzkellar

The story behind the famed Bratzkellar pizza pub on Lafayette Road began in 1975, not long after owners Chris and Christine Kamakas established the Dinnerhorn next door. These days, the business is run by Paul Kamakas, who has maintained the restaurant as one of the few places one can go in Portsmouth to get quality pizza and perhaps the coldest beer in town.

Charles "Bud" Gallagher

A longtime resident and business owner in Portsmouth, Gallagher started his first bicycle shop in his parents' basement at age 13; it went on to become Gallagher's Sport Center and P.J. Gallagher's. He also started Gallagher's Tire Center, Gallagher's Trophies, Team Sales, and numerous other entrepreneurial ventures. Later in his life, he continued to work daily at Gallagher's Place Shopping Center on Islington Street. (Courtesy of Kyle Morton.)

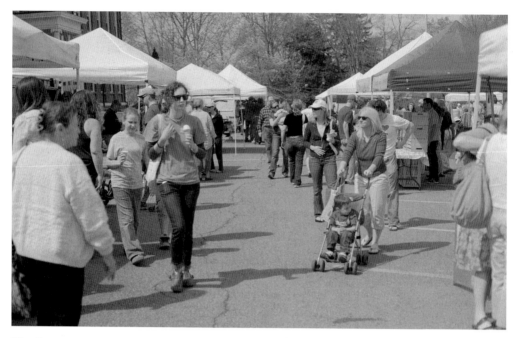

The Portsmouth Farmers' Market

In 1977, a small group of farmers came together with a radical new idea to support one another and their customers by creating a farmers' market in Portsmouth. The market eventually led to the formation of the Seacoast Growers Association, which has since spread throughout the region. Today, on every Saturday, farmers like Davyanne Moriarty, whose father was one of the founders, show up in town to sell the fruit and vegetables of their labor.

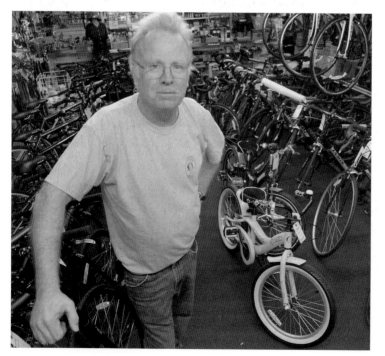

Bicycle Bob

As owner of Bicycle Bob's Bicycle Outlet on Route 1, Bob Shouse was the go-to guy for anything bicycle related in the Seacoast for nearly 25 years. Shouse, who learned how to repair bicycles as a boy from Charles "Bud" Gallagher, originally opened his first bicycle shop in Kittery, Maine, but eventually moved to Portsmouth. Despite his popularity, Shouse reluctantly closed his business in 2010.

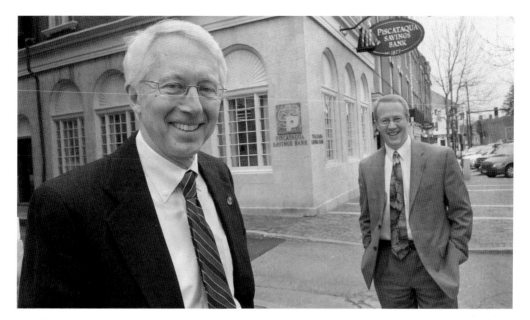

Jay Gibson

For 40 years, Jay Gibson (left) worked for the only mutual bank located in Portsmouth—Piscataqua Savings Bank. After starting out as a teller, he went on to spend 12 years as president/chief executive officer of the Market Square bank. He was a community leader before becoming bank president, having served with the United Way and Portsmouth Rotary. He retired from his banking career in 2012. Pictured at right is Jay's successor, Richard Wallis.

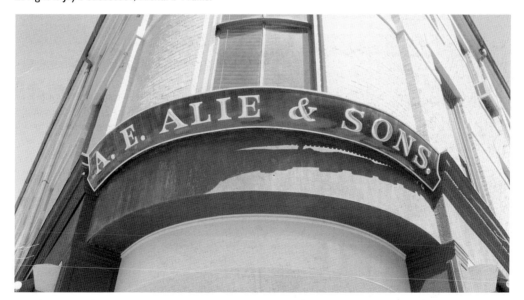

Alie Jewelers

As owner of Alie Jewelers, a family-owned jeweler since 1914, Stephen Alie epitomizes the idea of community. As the owner of a downtown business in Market Square, it not uncommon to see Alie outside of his establishment, either sweeping the sidewalk on a warm summer day or shoveling snow during any given winter storm.

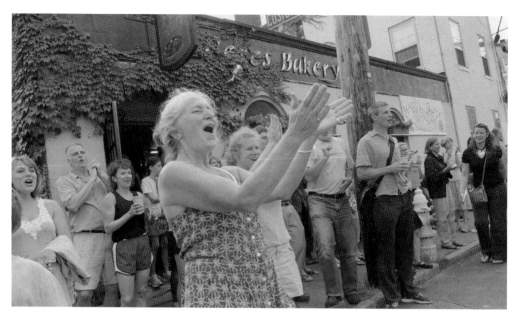

Ceres Bakery

In 2010, three decades after opening, Ceres Bakery owner Penny Brewster (front, center) was surprised by her loyal customers with a large celebration outside of the Penhallow Street business. Brewster, who moved to the area to study art at the University of New Hampshire, did not have any formal training as a baker but learned enough as a child watching her mother bake that she decided to open her own bakery.

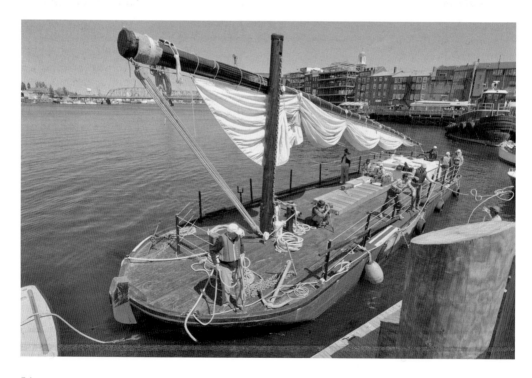

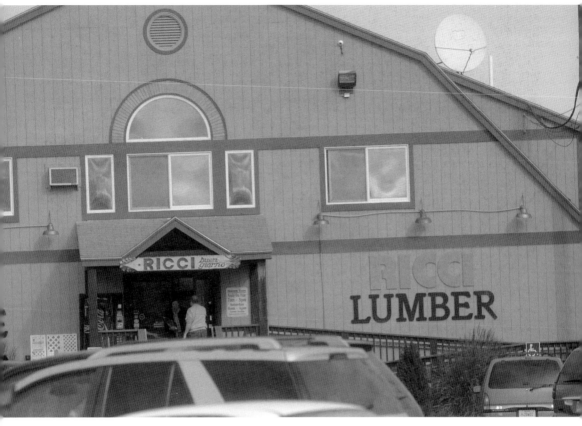

Ricci Lumber

Ricci Lumber was founded in 1956 by general contractor and real estate developer Erminio "Papa" Ricci and his son Robert "Bud" Ricci Sr. when they could not find a reliable lumber and masonry supplier for their construction company. At first, the company primarily sold brick, blocks, and bagged mortar and cement, but lumber and building materials were eventually added to complement the masonry store.

In 1960, Don Hayes, Erminio's son-in-law, joined the company and began working his way through the organization—from yardman to driver and eventually, general manager—during a career that would span more than 40 years. The elder Ricci died in 1982. Today, Ricci Lumber is still owned and operated by members of the Ricci and Hayes families.

The Gundalow Company (OPPOSITE PAGE)

The Gundalow Company was formed in 2002 to create educational programming around and in support of the *Capt. Edward H. Adams*, a gundalow launched in 1982. Molly Bolster, who became executive director of the Gundalow Company in 2003, said she considers it to be her dream job. A native New Englander, Bolster had been sailing since she was a child and has navigated waters near and far.

Sanders Fish Company

Earle Sanders got his start in the lobster business in 1951 as a truck driver for Jimmy Haig, a resident of Gates Street. Nearly a year later, in February 1952, Haig perished bringing a load of lobsters back from Monhegan Island on a boat that sank during a nor'easter snowstorm. After his tragic death, Jimmy's wife, Eleanor, kept the business going and kept Sanders as an employee. Nearly two years after her husband's death, Eleanor herself died, leaving Sanders to run operations for the family estate.

On January 1, 1954, Sanders officially founded Sanders Lobster Company after purchasing the Haig business, which included a house, truck, and car. With a leased dock platform on Pray Street, where Sanders Lobster Company is located today, Sanders made it his mission to continue his former employers' legacy. In 1968, Earle's son Jim began working in the family business part-time, a job he would continue to do during summer breaks through his junior high and high school years. After graduating college, Jim Sanders went back to work for the family business. Years later, he would be surprised when his father took him into the back room of the Pray Street business and asked him, "Do you want it?"

Jim Sanders then purchased the Sanders Lobster Company from Earle in 1989. Today, he continues to own the business as well as Sanders Mill Fish Market, which was called the Blue Fin Fish Market from the 1940s through the late 1980s and which Jim had purchased in 1987.

After operating it under the name Sanders Olde Mill Fish Market for more than 20 years, the Sanders family reopened the newly renovated and revitalized business as Sanders Fish Market in June 2008. Today, the business is run by Jim's son Michael.

Earle Sanders died at his home in October 2008, at the age of 79. During his life, he was an important part of the city's South End. When the Children's Museum of Portsmouth opened, he took it upon himself to get the beautiful clock in the tower running again, orchestrating and subsidizing its refurbishing. He and his wife also sponsored a very popular lobstering exhibit in the museum.

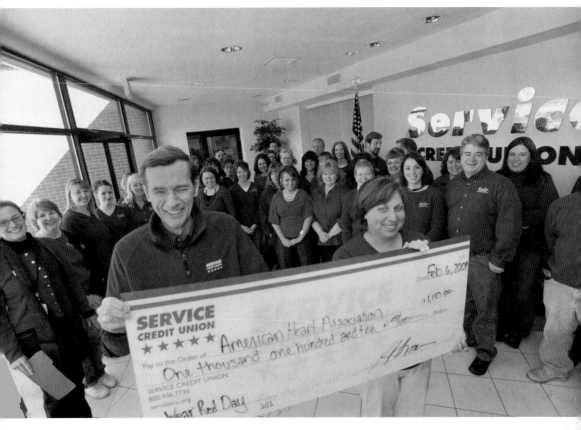

Service Credit Union

Founded in 1957, Service Credit Union was originally chartered to serve the military and civilian employees at Pease Air Force Base in Portsmouth. It was created by eight founders, each contributing $5. Its leader, Gordon Simmons, joined the credit union in 1974. Before becoming president, Simmons served in various capacities, including branch manager, vice president, and senior vice president. Through his leadership, the credit union has grown into the state's largest, providing financial services to more than 165,000 members with branches in New Hampshire, Massachusetts, and Germany. In 2012, the Service Credit Union Board of Directors dedicated its globe sculpture at its new corporate headquarters in Portsmouth to Simmons.

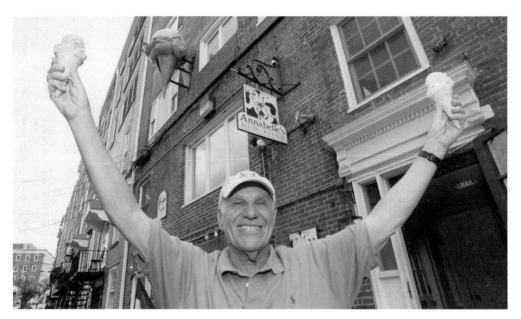

Annabelle's Natural Ice Cream
Annabelle's first opened on Ceres Street in June 1982. In 1992, Dr. Lewis Palosky (pictured) and his wife, Linda, bought the then 10-year-old business from Alex David. Previously, Palosky had been an optometrist. After more than 30 years, Annabelle's continues to get national attention in magazines and other media and has stood the test of time and the economy.

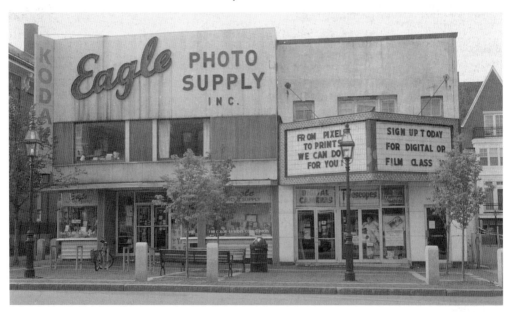

Eagle Photo
In 1915, Eagle Photo was founded by Louder Matossian. In the 1950s, Matossian's son-in-law Clyde Williamson moved the business from Daniel Street to a distinctive building on Congress Street, complete with marquee. The famed store moved out of the downtown to a new location on Islington Street in 2003. Five years later, it would close for good.

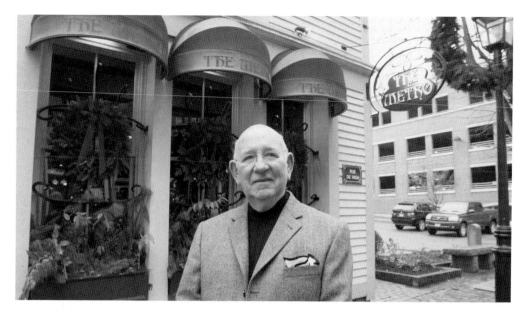

Sam Jarvis

As the former owner of the Metro, Sam Jarvis spent 30 years at the helm of one of the city's most popular restaurants. Jarvis, a lifelong Portsmouth resident whose family opened the Jarvis Tea Room in Market Square in 1928, was also a friend of the community, known for his generous contributions and gracious acts.

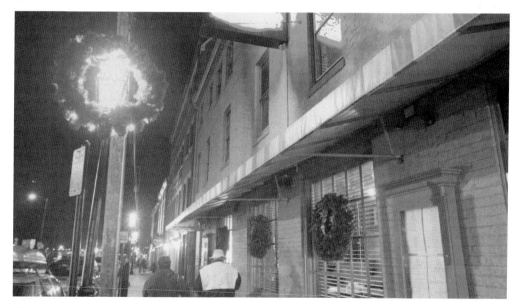

The Rosa

After 85 years in business, the Rosa Restaurant closed its doors on State Street in January 2012. Joe Hunt and his wife, Pamela, owned and operated the landmark Italian eatery for 30 years before deciding to close. Pamela died less than a year later, leaving Joe with all of the memorabilia and furniture the couple had collected during their tenure as owners of the Rosa. In 2013, the restaurant reopened under new ownership.

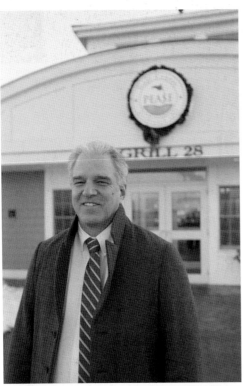

John Tinios

Tinios worked in the hospitality industry all his life. He took ownership of the Galley Hatch in Hampton in the early 1990s and then brought his passion for restaurants to Portsmouth, opening Popovers in 2006 and Grill 28 in 2011. In 2013, Tinos was named "Restaurateur of the Year" by the New Hampshire Lodging & Restaurant Association, and he credited the award to his passionate staff and a positive attitude.

Friendly Toast

Owned by Melissa and Robert Jasper, the Friendly Toast is the direct outcome of the couple's love for collecting mid-20th-century decor. Known for its food and its quirky collection of lamps, tableware, wall art, and other memorabilia from the 1950s, 1960s, and 1970s, the line outside the Jasper's establishment tells the true story of the restaurant's popularity. In 2012, it was named one of New England's "Best Breakfasts" by *Yankee Magazine*.

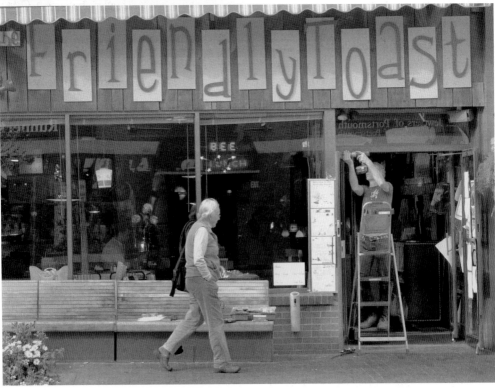

CHAPTER THREE

Champions

Champions can come in all shapes and sizes. Some win trophies for victory on the playing field or golf course; others earn their accolades in the form of praise for their accomplishments throughout the community.

In this chapter, readers will learn about the many men and women of Portsmouth who went on to earn their fame in the sports arena or in the world of charity, with the mission of making a difference. Included here are the high school boys and girls who became local celebrities for leading their school to state championships and national records, like the Portsmouth High School (PHS) varsity baseball team that went on to earn a national record for consecutive victories by a high school baseball team. Other legendary locals described made names for themselves at the national level, such as Jane Blalock, a city native who went on to win 27 times on the Ladies Professional Golf Association Tour. This chapter will also shed light on people like Constance Bean, an administrative assistant at the local community center on Daniel Street who was known for her love of local children and whose name is now synonymous with city youth and recreation.

In addition to these accounts of local champions in recreation and sports are those kinds of people who made a difference in their community. These include people like Joe Shanley, who through his volunteerism helped raised millions of dollars for many local organizations, and Amy DeStefano, a local woman who inspired the community during her battle to get a new heart.

Along with stories of individual accomplishment, this chapter will include tales of triumph from groups of people like the Save the Indoor Portsmouth Pool group, a grassroots organization formed in 2010 to ensure the survival of the city's indoor pool after it was slated to be closed because of budget cuts.

Constance "Connie" Bean

Connie Bean worked for the city's recreation department for 35 years, most of that time as administrative assistant. She was known for her caring and generosity—often giving out meals, money, or rides home to children in need. She was truly a champion of youth recreation.

Sadly, in the midst of helping others, Bean was diagnosed with mouth cancer in 1983 and died the following spring. The city promptly renamed the Daniel Street building she worked at the Connie Bean Community Center. "She just became a symbol of the recreation department. Connie Bean became synonymous with recreation," her son Rick Bean told the *Portsmouth Herald* in 2009. Her name graced the community center until 2012, when the city closed the building and reopened another youth recreation facility in her name.

Jane Blalock

Jane Blalock was born on September 28, 1945, in Portsmouth. She began playing golf at the age of 13 and went on to win 27 times on the Ladies Professional Golf Association (LPGA) Tour.

In 2000, she was recognized during the LPGA's 50th anniversary as one of its top-50 players and teachers.

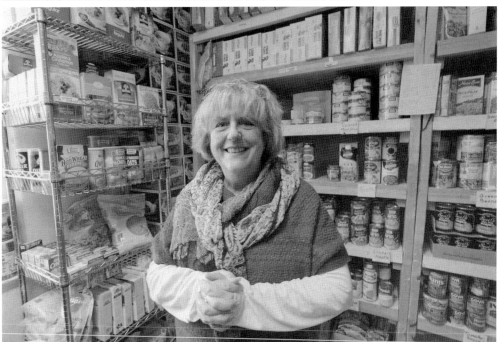

Seacoast Family Food Pantry

The pantry is the oldest social-service agency in New Hampshire. It was established in 1816 to assist families of fishermen, but over the years, the agency and its mission evolved. Today, it is run by executive director Diane Giese, who, with the help of volunteers, provides low-income individuals and families with food, personal-care items, and education for healthy living.

Joe Shanley

He was always the center of attention. Joe Shanley was a beloved husband, father, broker, and auctioneer, as well as a good friend of the community. As a boy, he attended St. Patrick School, a small Catholic school on Austin Street. The owner of Shanley Realtors since 1968, his professional resume included being past president of the New Hampshire Realtors Association, director of the Northern New England Real Estate Network, and a member of the New Hampshire Commercial Investments Board of Realtors.

Shanley was not only known for his dealings in real estate but also for applying his auctioneering skills over the years to numerous local nonprofits in need of a financial boost.

He routinely entertained at benefit events held by the Special Olympics, Cystic Fibrosis Foundation, Cross Roads House homeless shelter, New Hampshire Association of Realtors, Strawbery Banke Museum, Foundation for Seacoast Health, City Year New Hampshire, the local school system, and many other charities and private clients. He was also a past member of the board of directors for Big Brothers Big Sisters.

He raised millions of dollars for the many organizations throughout the years. Shanley was the recipient of the 2007–2008 Spirit of Seacoast Volunteer Award and received the Paul E. Harris Award from the Portsmouth Rotary Club. In 2008, he was recognized by Friends Forever as the inaugural recipient of the Eileen Foley Award, presented to citizens who have helped make the world a better place.

As master of ceremonies at the Annual Friends Forever St. Patrick's Day Roast, Shanley easily applied his gifts of humor and storytelling, becoming the highlight of the evening.

Throughout his life, his sense of humor and quick wit made him a unique member of the community. He was the opening act for celebrated comedian Steven Wright at the Music Hall.

Shanley died in November 2012 at age 59. His funeral drew more than 1,000 guests, and the Rotary Club of Portsmouth honored him with a new scholarship program created in his memory. As Rotary president Nancy Notis said, "There will never be another Joe Shanley."

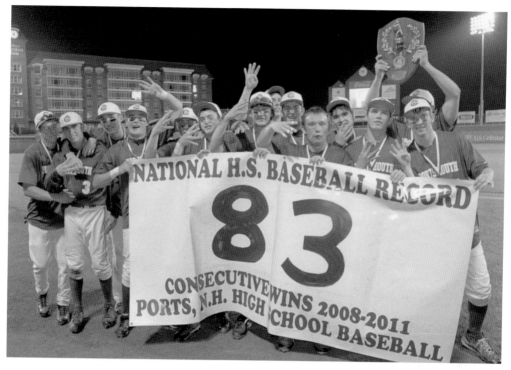

Portsmouth Clipper Baseball Team

They dominated baseball on the Seacoast and in the state for nearly five straight years with a winning streak that lasted from 2007 until one fateful day in August 2012. On that day, the Clippers lost to rival St. Thomas, 5-4. The narrow loss ended the team's national record-winning streak at 89 games. Weeks later, during a playoff game against Lebanon, the Clippers saw their run of four consecutive Division II championships end as well.

It was said that it took a "perfect storm" of factors for Portsmouth to accomplish what it had since the start of the 2008 season. Not only was the team filled with exceptional athletes and ballplayers, it also boasted a dedicated coaching staff centered on coach Tim Hopley.

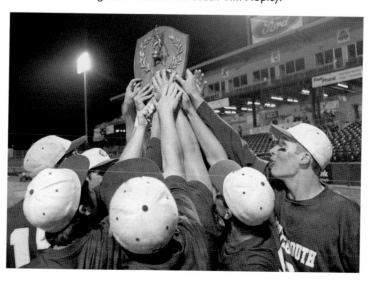

Portsmouth Football

When the third-seeded Clippers played Goffstown in their second-straight Division III title game on a chilly Saturday in the fall of 2012, it was the first championship game played at Portsmouth since 1976. The team made sure it was a memorable one, beating their cross-state rivals 54-27. The victory marked the continuation of what had been a longstanding, but sporadic, championship legacy for the city's football program. The Clippers, who had reached six of the seven championship games since joining the league in 2006, won the big game in both 2011 and 2012 under the leadership of Bill Murphy and his coaching staff.

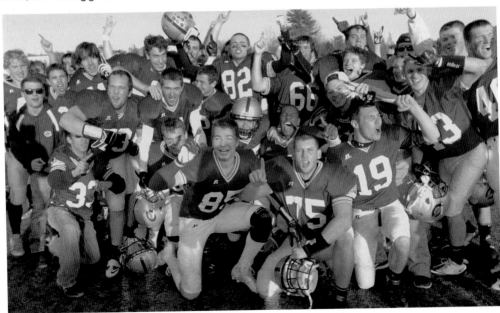

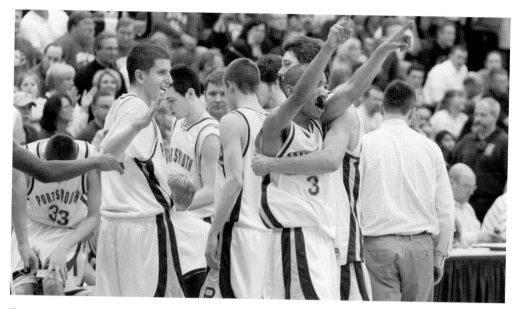

Portsmouth Basketball

In 2012, the Portsmouth High School boys' basketball team solidified its legacy as one of the premier boys' basketball programs in the state when it won its 18th state championship at Lundholm Gymnasium at the University of New Hampshire in Durham. The first championship for the Clippers came in 1923, and the latest, in 2012, came under coach Jim Mulvey.

The program has also experienced many close calls over the years. In addition to its 18 titles, the Clippers also boast 12 runner-up finishes. In 2013, the second-seeded Clipper boys were close to adding to the trophy case but ended up losing to Souhegan 69-65 in a close game in front of a capacity crowd at Stone Gym.

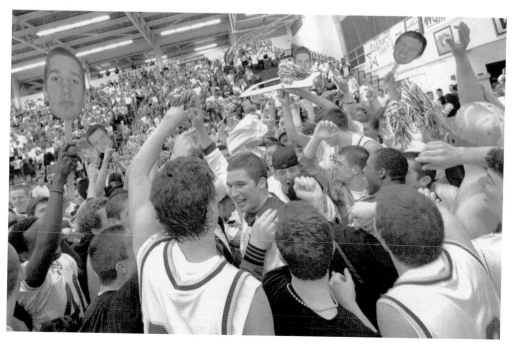

Pat McCartney

Pat McCartney was best recognized as the tall man with the beard, baseball cap on backward, crutches under his arms, and camera strapped to his chest. He was known as a selfless man who loved capturing the smiles and celebrations of city youth sports and recreation. McCartney was a common sight at Portsmouth High School sports games and at various events put on by the high school and city recreation department. He was a member of the recreation board until the day he died. He also served as president, vice president, and treasurer for the board of directors of the American Little League.

In addition to his administrative duties, McCartney also announced various youth and high school sports games over the public address system. In 1998, he was given the Mayor's Award and was named "Volunteer of the Year" with the state recreation department. He died in 2010 following a battle with a degenerative neurological disc disease.

Amy DeStefano

Her story captured the hearts of the people of Portsmouth and beyond. Amy DeStefano's battle to get a new heart made her one of the city's most beloved residents.

The mother of two was stricken in 2009 by a virus that attacked and damaged her heart and, since that time, had been forced to wait until her name came to the top of a donor list.

Finally, after years of waiting, DeStefano got her wish on December 31, 2011. It was on that day that DeStefano not only received a new lease on life but also became the first patient in New England to receive a heart through a new, experimental process called "Heart in a Box."

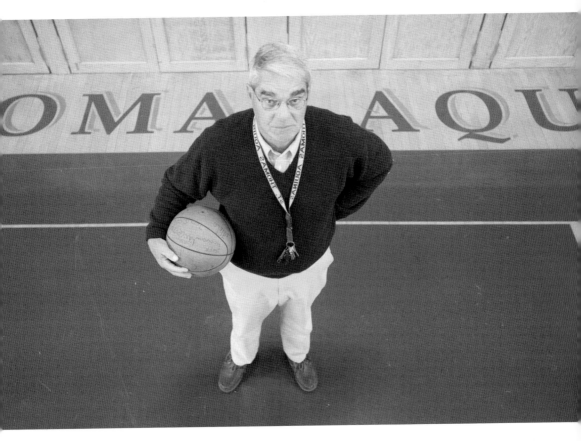

Dan Parr

He was Portsmouth's Mr. Basketball. Dan Parr, the dean of New Hampshire basketball coaches, has more than 600 wins, 5 state titles, and 9 trips to the finals under his belt. In 2011, he completed his 50th year as a basketball coach in the Granite State, by far the longest active tenure. That same year, he took over as the coach for the PHS Clippers girls' team for the second time, having previously coached the girls during the 1983–1984 season. Parr also coached the PHS boys' team for 12 seasons. In the 1970s, his teams advanced to the finals four times in a six-year stretch but never won a title.

Portsmouth Listens

The origins of Portsmouth Listens date to 1998, when local schools were seeking a way to involve the community on issues critical in education. Since then, the nonprofit, citizen-led organization has engaged more than 1,300 residents in eight major dialogues, producing 10,000-plus hours of deliberation on topics crucial to Portsmouth and beyond.

In 2010, the nonprofit was named as a finalist in the Reinhard Mohn Prize 2011 "Vitalizing Democracy Through Participation" competition. In 2011, Portsmouth Listens was selected to receive the Sarah Farmer Peace Award. Jim Noucas (a local lawyer) and John Tabor (publisher of Seacoast Media Group, which prints the *Portsmouth Herald*) served as cochairmen of the nonprofit over the years.

Save the Indoor Portsmouth Pool

The grassroots organization known as SIPP formed in 2010 to ensure the survival of the city's indoor pool, which was scheduled to be closed because of budget cuts. The group lobbied the city council, improved the pool, and increased the number of users.

SIPP's private/public partnership with the city was viewed nationally as a model to save other pools around the country in danger of closing because of budget reasons. In 2011, the group signed a five-year lease agreement with the city. The agreement required SIPP to raise a minimum of $750,000 for capital improvements and repairs. As part of its partnership with the city, SIPP pledged to replace the pool's aging roof.

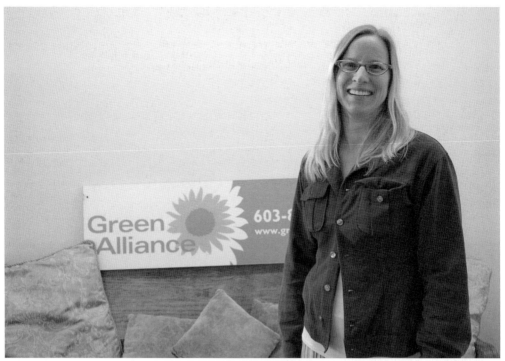

Sarah Brown

A Portsmouth native, Brown is most known for her work on community environmental issues.

She became active in environmentalism after returning from Russia, where she had spent five years as a journalist, in 2001. In 2008, the well-known community activist created the Green Alliance, an effort designed to create partnerships with businesses that make environmentally conscious choices.

The Reverend Dr. Arthur Hilson

Arthur Hilson is a veteran of the civil rights struggle and a common leader in faith.

Hilson once marched with Martin Luther King Jr., and to this day, he shepherds the New Hope Baptist Church on Peverly Hill Road in Portsmouth. In addition to teaching at Portsmouth High School, he also helped found the local chapter of the Southern Christian Leadership Conference.

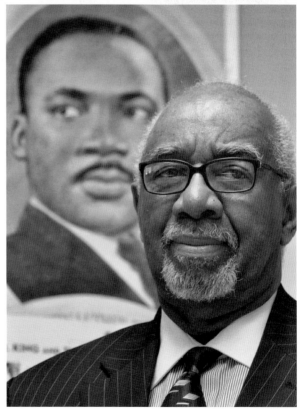

Renee Riedel and Danny Plummer

"Nobody believed it could be done."

Renee Reidel-Plummer and Dan Plummer, owners of Two International Group, did it, however. The duo of developers can be credited with helping transform land at the former Pease Air Force base—a feat many considered to be a gamble—into a burgeoning business park that today is filled with business and commerce. The transformation is considered to be one of the most successful in the state, if not the country. Since starting out in 1997, the pair has been responsible for 18 buildings and has developed more than 70 acres at the Pease. Today, the group claims more than 250 tenants and counting.

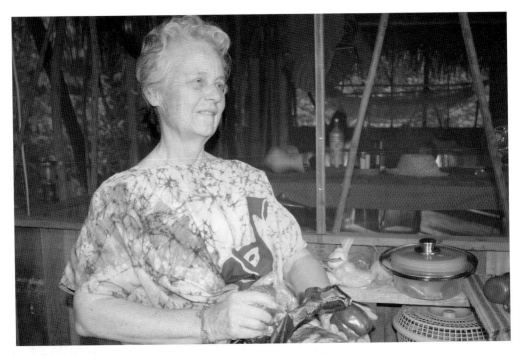

Diane McCormack Seagren
Recognized for her giving spirit and humanitarianism throughout the world, Diane McCormack Seagren was truly a fixture in the community. She died in March 2010 while in Belize. Shortly after her passing, she was honored posthumously by the Great Bay Chapter of the American Red Cross for helping local children with special-education needs as well as families in Central America struggling to put food on the table. (Courtesy of Sustainable Harvest International.)

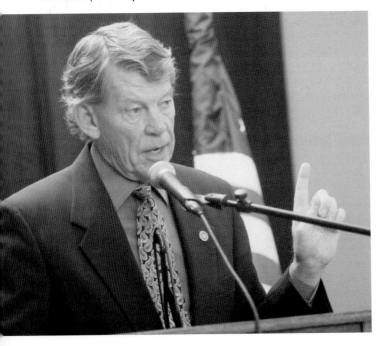

Leonard Seagren
For more than 20 years, Leonard Seagren ran the landmark downtown cigar shop, Federal Cigar.

He took over in 1981 and was well known for running the popular matchbook poll, which allowed customers to weigh in on any given election. After selling the shop in 2010, Seagren continued to focus his efforts on public service, including getting involved with the Friends Forever program.

Tom Daubney
Longtime coach Tom Daubney helped guide the Portsmouth High School football program from 1970 to 1992. During one 14-year span under his leadership, Portsmouth played in six championship games. He led the Clippers to state championships in 1976, 1977, and 1981. In addition to coaching, Daubney also served as instructor of the popular PHS course Project Adventure. The football field at Portsmouth was dedicated in his name in 2005. (Courtesy of John Huff.)

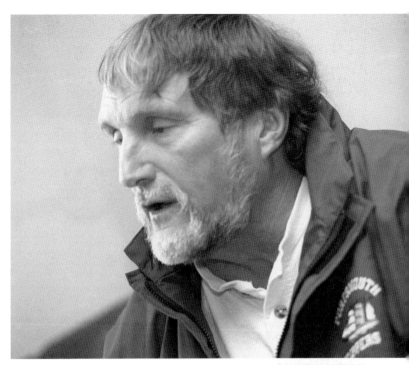

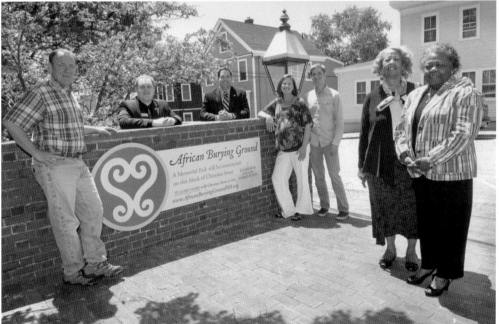

Vernis Jackson
Jackson (far right), a southern girl, came to the Portsmouth community in 1963 and spent more than three decades teaching in area schools. She also supported and helped launch a number of important community endeavors. Her most notable accomplishment is the Seacoast African American Cultural Center in Portsmouth, which today has become an important part of the city's cultural landscape.

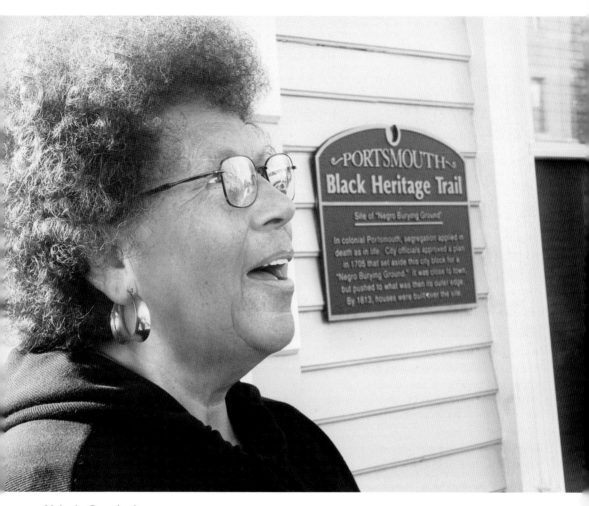

Valerie Cunningham

Local historian, scholar, author, leader, and Portsmouth native Valerie Cunningham is founder, former president, and executive director of the Portsmouth Black Heritage Trail, Inc. Her research laid the foundation for the first such history trail in northern New England. She also was involved in efforts to establish a memorial at the African Burying Ground on Chestnut Street.

Cunningham coauthored *Black Portsmouth: Three Centuries of African-American Heritage* and has written a number of articles about black history in New Hampshire.

She was honored in June 2008 as a Restore America Hero at a ceremony at the Library of Congress.

Karina Quintans

Since moving to Portsmouth in 2007, Quintans has quickly become one of the city's most influential community organizers. She served as the neighborhood organizer for the Islington Creek Neighborhood Association, working to educate her neighbors on issues such as traffic and safety, crime prevention, zero waste, and sustainability. She has also served on the Mayor's Blue Ribbon Committee on Sustainable Practices and is the director of Zero Waste Portsmouth.

Jameson French

A longtime resident, French is most known for his distinguished business sense, environmental awareness, and lengthy record of giving back to the community. He was the driving force behind the community campaign to restore the Market Square Steeple, and he helped found the Music Hall. French also served as the past chair of both the Society for the Protection of New Hampshire Forests and the Strawbery Banke Museum.

79

Erik Anderson
Throughout his career on the sea, Erik Anderson served as a voice for the local fishing community. Anderson, president of the New Hampshire Commercial Fishermen's Association and captain of the Fishing Vessel *Kris N' Kev*, used to be a ground fisherman but eventually refocused his efforts on lobstering in 2006.

Jeremy D'Entremont
D'Entremont (left) has been called the leading expert on New England's historic lighthouses. An author, lighthouse historian, and founder of Friends of Portsmouth Harbor Lighthouse, D'Entremont also served as historian for the American Lighthouse Foundation and has appeared on the History Channel, the Travel Channel, Public Television, and National Public Radio speaking about his love for lighthouses.

Macy Morse

As a nonviolent peace and antinuclear activist, Morse was most known for her ability to protest. In addition to protesting the Vietnam War, Morse spoke out against the Seabrook nuclear power plant, AVCO missile production, and the wars in Iraq and Afghanistan.

In 1980, she spent 30 days in jail in Richmond, Virginia, for spraying antinuclear slogans on pillars at the Pentagon. She was also arrested in 2002 when she and four others performed a sit-in at a US senator's office, and in 2006, she participated in a similar protest at a US congressman's office and was again arrested for her protest of the war in Iraq.

Angelo Pappas
Over his 18 years in Portsmouth, Angelo Pappas not only was priest of St. Nicholas Greek Orthodox Church but also served the Seacoast and statewide communities as chaplain for the city's police and fire departments. Known as "Father Angelo," Pappas also served on the Portsmouth Rotary Club and was appointed to the Council for Suicide Prevention by Gov. John Lynch.

Bert Cohen
A former teacher at Little Harbour School, Cohen introduced the idea of a sustainability framework to Portsmouth's master plan. He helped foster the growth of Natural Step Study Circles in the Piscataqua Region. In 2007, he was honored with the Sarah Farmer Peace Award for his work as cofounder of Piscataqua Sustainability Initiative and a collaborator in Portsmouth Listens Study Circles.

Joe Couture

Joe Couture, who served as director of the city's housing authority for almost seven years beginning in 2006, was credited with making it the "jewel" of all housing authorities in New Hampshire. "It's time to enjoy some life," Couture said about his plans for life after retirement in 2012. Pictured from left to right are Ruth Griffin, Craig Welch, and Joe Couture. (Courtesy of Portsmouth Housing Authority.)

Ted Alex

A local Rotarian, Alex started the Jeremy Alex Fund in memory of his late son, who disappeared in 2004 at the age of 28. Because one of his son's interests involved chess, Alex created the fund to ensure that all fourth graders in the city would receive a chess set.

Steve Schulten

For nearly 40 years, Schulten served as both an educator and mentor to local schoolchildren.

He joined the school district in 1973 when he was hired as a driver's education instructor at the high school. In 1990, he started as Little Harbour's gym teacher, a post he held until his retirement in 2012.

Schulten was also known as a community leader, organizing barn dances, and being involved with projects such as Students Against Destructive Decisions and Jump Rope for Heart. He founded the chess club at Little Harbour in 1995 and made annual trips to Belize, where he helped local children obtain chess sets and scholarships to attend high school.

William Henson
Portsmouth native William Henson helped solidify the Mark Wentworth Home's position as a nonprofit leader in senior services in the Seacoast. Henson joined the Mark Wentworth Home's board of trustees in 2001 and served as its president from 2004 to 2009. In 2011, he stepped down from the board and became the home's chief operating officer. In 2012, Henson was named president and chief executive officer of the nonprofit.

Maj. Chet Emmons
During his time at the local Salvation Army, Maj. Chet Emmons truly made a difference for those less fortunate. Emmons, along with his wife, Joy, spent four and a half years at the Salvation Army on Middle Street. Whether it was hosting soup kitchens, running the annual red kettle campaign, or holding holiday parties for local children, the Emmonses surely left their mark in Portsmouth. The couple was reassigned to a different post in 2010.

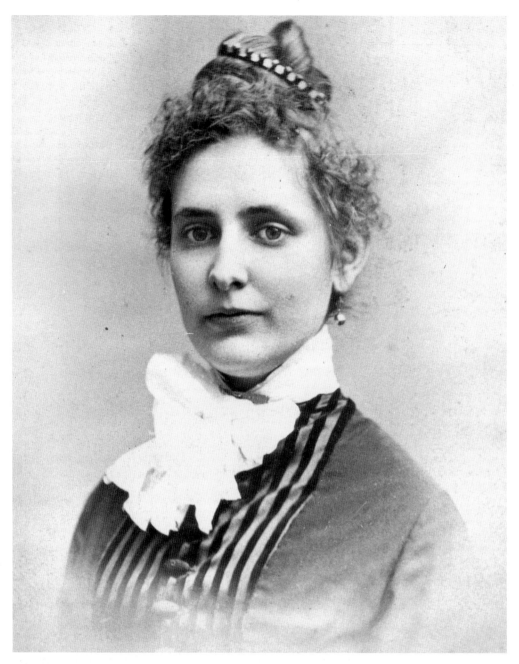

Josie Prescott

Josie Prescott is directly responsible for the creation of what is now known as Prescott Park. She and her sister were both public school teachers and lived in Portsmouth all of their lives. Prescott received a sizable inheritance following the death of their older brother Charles, and in her last will and testament, she left a private trust fund of $500,000 for the beautification of the waterfront section along Marcy Street. The trust's sole purpose was to purchase land parcels along the Piscataqua River from lower State Street to Pickering and Gates Street and to turn the land into a public park. (Courtesy of Portsmouth Athenaeum.)

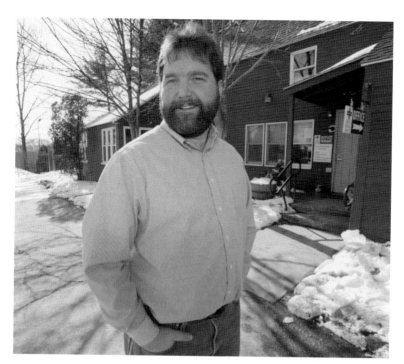

Chris Sterndale
Since joining Cross Roads House in 2000, Sterndale has been the face of helping the homeless in Portsmouth and throughout the Seacoast. As executive director of the local homeless shelter, he worked to ensure no one goes without a warm meal or a safe place to sleep for the night.

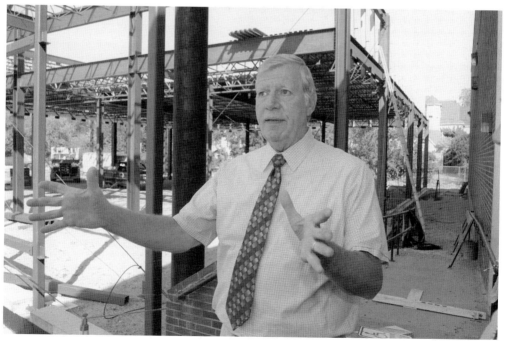

John Stokel
After becoming principal at Portsmouth Middle School in 1981, John Stokel was often the first person students would see at the beginning of every school day. In 2012, Stokel was nominated for and recognized as the "Outstanding Role Model of the Year" by the New Hampshire Association of School Principals. The award recognized Stokel for being a "local, if not national, treasure."

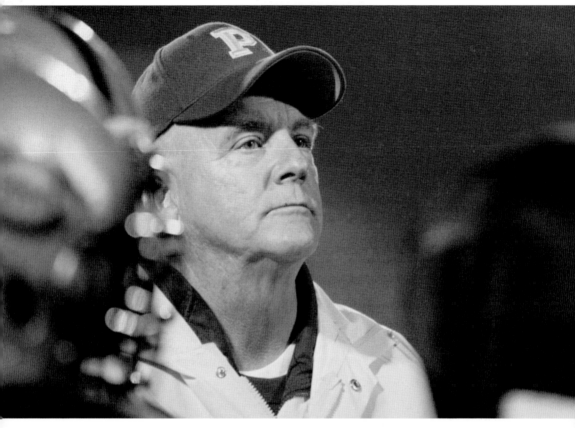

Bill Murphy

Bill Murphy's career at Portsmouth High School began in 1964 as a starting defensive back on a team that would go on to win the Division I championship. Years later, in 1972, after graduating from the nearby University of New Hampshire, Murphy was hired as the freshman football coach at PHS. It was the beginning of what would be a 41-year coaching tenure.

In 2011, 47 years after celebrating a Division I championship as a player, Murphy won his elusive first state title as a head coach in Division III. He would go on to win a second consecutive state championship in 2012.

Nancy Notis
In addition to her role as spokesperson for Portsmouth Regional Hospital, Nancy Notis has found her niche within the community through various civic involvements over the years. Not only was she named president of the Portsmouth Rotary Club, she also helped organize the annual Greek Festival for the St. Nicholas Greek Orthodox Church.

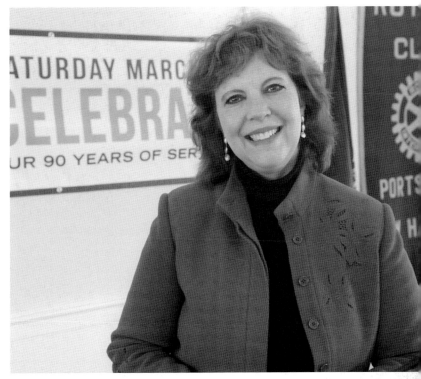

Lisa DeStefano
As a notable local architect, DeStefano has left her mark pretty much all over the city. Born and raised in Portsmouth, she launched DeStefano Architects in 1996. Since that time, she has helped influence the look and feel of the downtown area with projects including 100 Market Street and the Porter Street townhouses.

Charlie Griffin

Portsmouth lost a true icon when Griffin passed away in September 2008, just weeks before his 101st birthday. Griffin grew up in the South End, attended St. Patrick School, and graduated with the Portsmouth High School class of 1926. He also worked in the street, pedaling the *Portsmouth Herald* for 2¢ a copy.

A lifelong resident, Griffin volunteered at Portsmouth Regional Hospital and is said to have brought comfort and cheer to patients young and old. He was most known for his collection of more than 80 hats, one being a chicken, as well as for the "Weebles" he gave to patients.

CHAPTER FOUR

A Cultural Melting Pot

Without arts and culture, Portsmouth would certainly not be what it is today. From the people who painted the many murals throughout the city to the poets who put pen to paper to describe their love for this historic community, the legend of Portsmouth would be incomplete without its collection of creative individuals and arts organizations.

This chapter will highlight many of the artists, musicians, and writers who had an influence on the city's arts and culture scene. It will give readers a front-row seat at the many music halls, clubs, art galleries, and performance stages throughout the Port City and will focus on such historical people as Thomas Bailey Aldrich, an American poet, novelist, travel writer and editor, and Celia Thaxter, a city native who lived most her life on the Isles of Shoals and became one of the more celebrated poets of her time.

The story of Portsmouth's past artistic accomplishments also includes people like Robert Dunn, a man who for more than 30 years walked the streets of the city while writing poetry in his head and became known as the "Penny Poet of Portsmouth." Also included are tales of transformation from people like Ben Anderson, a man who took over as the leader of Prescott Park Arts Festival in 2007 and completely transformed the nonprofit arts organization, and Patricia Lynch, a woman who, from the second she became executive director of the Music Hall in 2004, helped revamp the downtown performance venue into one of the most popular cultural destinations in New England.

In addition to these leaders in arts and culture, this chapter will shine a spotlight on the many personalities of Portsmouth, such as John Herman, a man who in 2010 was dubbed "a new media guru" by the *Boston Globe*, and Marian Marangelli, a woman who was larger than life both on and off the performing stage.

THOMAS BAILEY ALDRICH 61
ARMSDEN

Thomas Bailey Aldrich

Thomas Bailey Aldrich was born in Portsmouth on November 11, 1836, to Elias and Sarah Aldrich, both of whom were considered descendants of Colonial New England families. Aldrich moved away from Portsmouth at the age of five but returned again for school at the age of 13. From 1849 to 1852, he lived with his grandfather in the "Nutter House," which is now named Strawbery Banke's Aldrich Memorial in his honor.

With aspirations to one day going to Harvard and studying under Longfellow, he attended the Samuel De Merritt school. However, his plans came to a screeching halt when his father died of cholera, leaving the family in a difficult financial predicament.

At the age of 16, Aldrich had his first poem published in the *Portsmouth Journal*. In 1852, he once again left Portsmouth and took off to New York City, where he worked for his uncle for a short time but continued to write. By this time, Aldrich had been published in various periodicals. Eventually, he was able to leave the business world and focus on his craft.

He worked as a journalist for a time and became part of what was known as the "lively literary scene."

After a stint during the Civil War as a war correspondent for the *New York Tribune*, Aldrich would return home to Portsmouth and spend the next several years writing.

His literary career would change dramatically in 1868 when he finished *The Story of a Bad Boy*, an important piece of American literature that he had begun while visiting Portsmouth. It was a groundbreaking work that told tales of boys gone wild, and Mark Twain credited the story as the inspiration for Tom Sawyer and Huckleberry Finn. Portsmouth was the setting within the novel, and Aldrich was said to be the "bad boy," writing, "This is the story of a bad boy. Well, not such a very bad, but a pretty bad boy; and I ought to know, for I am, or rather I was, that boy myself."

In 1883, Aldrich published *An Old Town by the Sea*, a historical memoir and guide to his 19th-century hometown of Portsmouth. He died in his home in Boston in March 1907. He was 70. (Courtesy of Portsmouth Athenaeum.)

Robert Dunn

For 30 years, Dunn was known for walking the streets of Portsmouth while writing poetry in his head. From 1999 to 2001, he was the poet laureate of the city. During his tenure, he organized a poetry festival, instituted monthly poetry hoots, and installed poetry in public places—notably, the parking garage. "It is sort of a bleak place," he said at the time. "I thought it could use it."

Dunn earned his moniker as "the Penny Poet of Portsmouth" because he produced hand-sewn booklets of his poetry that he sold for a penny. Dunn died August 31, 2008, at age 65. (Courtesy of Portsmouth Athenaeum.)

Bruce Pingree

For more than 30 years, Pingree helped showcase local musicians with jazz, blues, folk, R & B, and Latin jazz performances every night of the week at the Press Room on Daniel Street.

Not only did he help found WSCA Portsmouth Community Radio, he also helped organize local cultural events, including the Jazzmouth Poetry & Jazz Festival, RPM International Music Challenge, and the Portsmouth Halloween Parade.

Peter Happny

In 1971, Happny came to Portsmouth to take a job in the blacksmith's shack at Strawbery Banke.

After spending a few seasons working at the historic tourist destination in the city's South End, Happny decided he would make a career out of it. Since 1978, he has been known as the local blacksmith and has thrived at his studio located in the dense, downtown neighborhood on Rock Street.

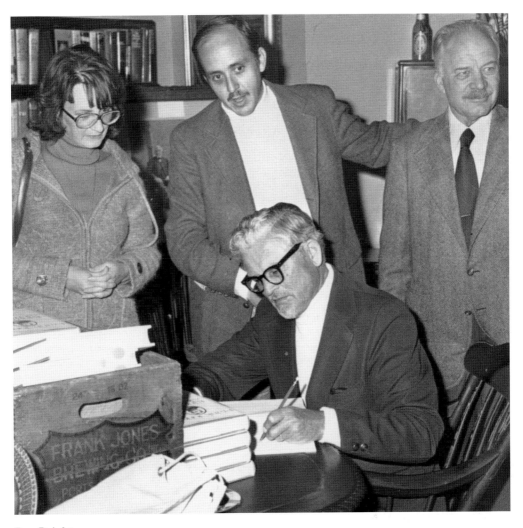

Ray Brighton
Brighton joined the *Portsmouth Herald* in 1946 and spent the next 33 years working there in various capacities. In his final 10 years with the paper, he served as the paper's editor and became known for his columns on local affairs. He retired in 1979.

Following his career in the newspaper business, Brighton became one of the city's most respected historians. He wrote about Frank Jones, the city's past as a major shipbuilding port, and, in 1973, he wrote *They Came Here to Fish* in anticipation of the 350th anniversary of the settlement of Portsmouth. The book is said to be the most complete story of Portsmouth's past.

Later in life, Brighton received the Golden Quill award from the New England Chapter of the Society of Professional Journalists. He died in 1997. (Courtesy of Portsmouth Athenaeum.)

Juston McKinney
A Seacoast native, McKinney grew up in both Portsmouth, New Hampshire, and Kittery, Maine.

In 1997, he moved to New York for what would be the launch of his illustrious comedy career. From there, McKinney gained notoriety for his humor and began to make regular appearances of late-night talk shows. He moved back to New Hampshire in 2004 but continued to perform all over the country.

Chase Bailey
In 1999, Bailey began to devote himself to his true loves—art and film. As general manager of independent film company Left Bank Films, he spent considerable time in Portsmouth as a developer, writer, producer, director, and actor. Throughout his career, Bailey worked with many actors, including John Malkovich, Johnny Depp, and John Goodman. He won "2009 Film of the Year" at the New Hampshire Film Festival for *Crooked Lanes*.

Tom Bergeron

Tom Bergeron got his start working at WHEB-FM radio in Portsmouth in the 1980s and went on to win an Emmy award for hosting a reality-competition program called "Dancing With the Stars." In 2009, he released his book *I'm Hosting as Fast as I Can!: Zen and the Art of Staying Sane in Hollywood.* The book was said to have deep ties to Portsmouth.

"Portsmouth is very important to me and very important to the story," Bergeron said in an interview in 2009. "Apart from the fact that I fell in love with Portsmouth itself . . . it was in Portsmouth at HEB where I was encouraged to find my own voice. They really gave me enough rope to hang myself. They were very encouraging. It's when I really said 'This is what I want to do.'" (Courtesy of ABC.)

Ben Anderson

In 2007, Anderson became executive director of the Prescott Park Arts Festival (PPAF) and completely transformed the nonprofit arts organization. Under his leadership, the festival's membership has tripled, business sponsorship and investment have risen 200 percent, and overall revenue has increased by 70 percent. Anderson has helped launch numerous collaborations, events, and initiatives during his short time with PPAF, with some of the most popular events being Shakespeare in the Park and Movies in the Park. Perhaps his most evident accomplishment is the River House Restaurant Concert Series, a performance in the park that began to attract thousands of guests to hear both renowned and emerging artists.

In 2012, Anderson was honored with the Paul Harris Fellow by the Portsmouth Rotary Club for his leadership in the community.

Patricia Lynch

When Lynch arrived as executive director of the Music Hall in 2004, the downtown performance venue was little known beyond the Seacoast. Over the years, however, Lynch helped transform the historic theater into one of the most popular cultural destinations in New England.

Not only did she help establish the successful Writers on a New England Stage series, she was also responsible for the Intimately Yours music series and A Vintage Christmas in Portsmouth, a popular holiday event held in partnership with Strawbery Banke Museum and area businesses.

Lynch was also behind the purchase of the Loft, a space on Congress Street that became home to Music Hall offices and expanded space for programming: workshops, talks, classes, and performances.

Bruce Ingmire

In 1978, Ingmire created the Market Square Day Historic Walking Tour. On the eve of every Market Square Day, Ingmire would stand in front of North Church and wait for the public to gather for one of his signature historical tours of downtown Portsmouth. His last Market Square Day tour talk came in 1992, the year of his death, and the tour was named for him in 1993. (Courtesy of Portsmouth Athenaeum.)

Wendell Purrington

After 35 years serving in various roles throughout the school district, Wendell Purrington (pictured at piano) said goodbye to his career as an educator in 2011. In addition to serving as the choral director at Portsmouth High School, he also worked in each Portsmouth school and helped with nearly all PHS plays. During his three decades in Portsmouth, Purrington also lead in church and community choirs and appeared in the Prescott Park Arts Festival.

J. Dennis Robinson

More of an explorer than anything, Robinson became most known in Portsmouth over the years for his keen interest in history. An educator, audio and video producer, lecturer, and columnist, Robinson has written extensively about the history of the Seacoast. He is editor and owner of www.SeacoastNH.com and has published more than 1,000 articles on local history and culture.

Sumner Winebaum

A graduate of Portsmouth High School, Winebaum went on to become a civic leader in the city. In addition to his philanthropy, he also emerged as a well-known sculptor, and his work can be found all over the Seacoast. In 2011, he unveiled a three-foot-high bronze sculpture, *The Hands of Hope*, at Temple Israel in Portsmouth.

John Herman

In 2010, the *Boston Globe* dubbed him "a new media guru." Herman, a local artist, writer, and media maker, became infamous for his passionate new media projects in and around Portsmouth.

In 2012, he was selected as one of five finalists out of thousands who entered a nationwide Space Race 2012 contest. That same year, he was named grand marshal of the Portsmouth Halloween Parade.

Larry Yerdon

In 2004, Yerdon arrived at the Strawbery Banke Museum fresh off a stint with Hancock Shaker Village. His arrival marked the beginning of a new and financially healthy future for the South End museum. Under his leadership, Strawbery Banke has become a living-history attraction that routinely draws thousands of tourists to Portsmouth year after year.

Marian Marangelli

She was larger than life, both on and off the stage.

As one of the community's top comedic personalities, Marangelli became known as one of the few "funny ladies" on the Seacoast. She was noted for her broad comedic style and impeccable timing. She performed in many productions at the Prescott Park Arts Festival, West End Studio Theatre, and Players' Ring, just to name a few.

Marangelli was acknowledged as "Volunteer of the Year" numerous times at Prescott Park for her work "hauling trash, selling tickets, working on sets."

Her day job was often as a cook, and she owned Celebrity Sandwich for two years.

Tragically, Marangelli died of respiratory failure at the age of 45 in 2011. Her passing cast a shadow over the Seacoast theater community, leaving it a lot less funny without one of its brightest stars.

Celia Thaxter

Celia Thaxter was born in Portsmouth in 1835 and lived most of her life on the Isles of Shoals, except for the early period of her marriage to husband Levi, which was spent in Newton, Massachusetts. A celebrated poet in her day, Thaxter believed that art should be available to and enjoyed by the masses. She died in 1894 at the age of 59. (Courtesy of Portsmouth Athenaeum.)

Pro Portsmouth

The nonprofit Pro Portsmouth was established in 1977 when a group of community leaders came together to hold the first Market Square Day, an all-day event created to celebrate the renovation and beautification of downtown Portsmouth. Over its more than 35 years in existence, the organization became a cultural cornerstone for additional events, like Children's Day and First Night, thanks to its hundreds of volunteers.

Jeanne McCartin

She was most known in the community for her role as Gossip Lady, a persona she donned while working as a freelance arts-and-culture writer for Seacoast Media Group. As Gossip Lady, McCartin would conduct interviews that most always included interesting interactions and conversations with local celebrities and members of the Portsmouth community.

Rachel Forrest

A former restaurant owner and world traveler, Forrest became most known in Portsmouth as the food-and-dining editor for Seacoast Media Group. Her weekly column and restaurant review, Dining Out, helped local diners get to know the hundreds of food establishments in Portsmouth and throughout the Seacoast.

Lindsey Altschul
Romance and a love for the culinary scene in Portsmouth led Lindsey Altschul to the Seacoast in 1998. From that time, Altschul became a popular restaurateur on the Seacoast as well as a beer connoisseur. As owner of the nearby Pepperland Café in South Berwick, Altschul was known to be quick with a handshake or a hug.

Tragically, Altschul died in May 2012 at the age of 52. His spirit continued to live on, however. Not long after his passing, Portsmouth-based Smuttynose Brewing Co. released a special brew in his memory. The beer, a German-style Kolsch, was called Lindz in honor of Altshul's nickname and was released at restaurants throughout New Hampshire and Maine.

Portsmouth Athenaeum (OPPOSITE PAGE)
The nonprofit membership library and museum was incorporated in 1817 and located in the heart of downtown Portsmouth. Membership libraries were first created in the 18th century, and today, the Athenaeum is led by its keeper, Tom Hardiman (pictured), who continues the long tradition of protecting the city's history by maintaining a library of more than 40,000 volumes and an archive of manuscripts, photographs, and objects relating to local history.

Portsmouth Historical Society

Established in 1920 as one of the city's first museums, the Portsmouth Historical Society is the only institution focusing on the history of the entire community. In 2011, the nonprofit organization appointed Maryellen Burke to fill its new executive director position. Under her leadership and that of people like Richard Candee and Sandra Rux, the historical society grew in membership and popularity.

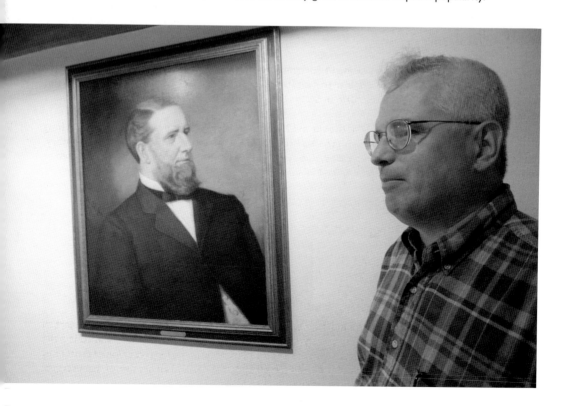

Seacoast Repertory Theatre

As a nonprofit arts and educational institution, the Seacoast Repertory Theatre ("the Rep") was first started in 1988. Prior to its incorporation, its offices and performance space served as the warehouse for the Portsmouth Brewing Company. The site is also the former home of Theatre By The Sea.

There is really not one person who makes up the local theater. Rather, it is run by a collection of dedicated individuals and a board of directors that includes the likes of Chase Bailey, Sumner Winebaum, and Craig Faulkner.

In 2013, the Rep celebrated its 25th anniversary, which marked 3,400-plus main-stage shows, nearly 100 youth shows, and 250 special events with somewhere around 12,000 children served, plus thousands of seniors enjoying lifestyle-specific programming and productions.

CHAPTER FIVE

Tragedy and Triumph

The heroic sacrifices and bravery of many are a major part of the Port City's history. Unfortunately, so are tragedies. This chapter will present some of the men and women who either served their country in the armed forces or served their community through law enforcement or public service. It will include a look at some of those who donned a badge, picked up a fire hose, or took up arms as a member of the Portsmouth community.

This chapter will give readers a glimpse at everyone from John Paul Jones, a legendary naval fighter in the American Revolution, to Gen. Fitz John Porter, a native who became most famous for his military service and for the controversy that surrounded him during the Civil War.

Also included are people like Kevin Semprini, a man who came to be known as "Officer Friendly" for his community relations and his notable work as school resource officer for Portsmouth elementary schools, and Sal Zona, a man who dedicated his life in the local community to cutting the hair of the men and woman of the armed forces stationed at Pease Air Force Base. Additionally, readers will learn about the Pease Greeters, an all-volunteer group of veterans and civilians who, since 2005, would show up to Portsmouth International Airport to welcome troops both coming home and heading overseas.

Among the tragic stories of Portsmouth are those of Sarah Fox, a celebrated veteran of the Portsmouth Fire Department who was diagnosed with cancer in 2007 and died four years later, leaving the community heartbroken, and Laura Kempton and Tammy Little, two beauty-school students whose brutal murders were never solved by local police.

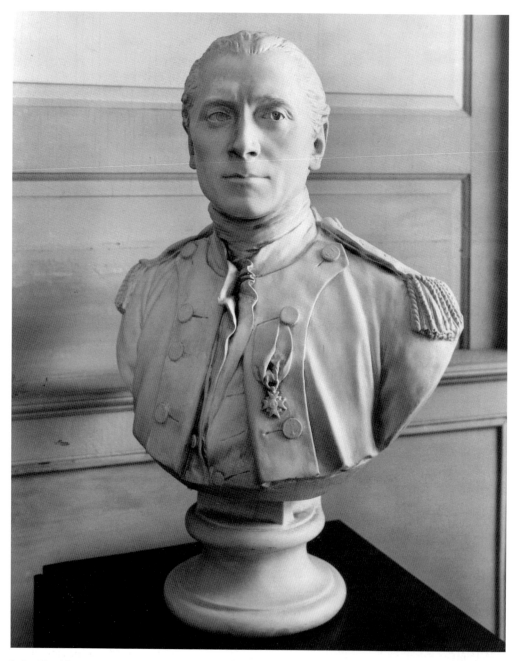

John Paul Jones

Naval hero John Paul Jones—perhaps most famous for his words, "I have not yet begun to fight!"—was born in Scotland, though he had Portsmouth ties. A fixture in the American Revolution, he spent time in Portsmouth in 1777 while his warship *Ranger* was being built on Badger's Island and again from 1781 to 1782 while *America* was under construction at John Langdon's shipyard.

Also known as the "Father of the American Navy," Jones is believed to have rented a room in a house on Middle Street. Today, that structure is known as the John Paul Jones House. (Courtesy of Portsmouth Historical Society.)

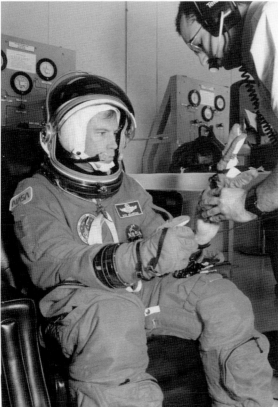

Bill Mortimer

Bill Mortimer, or "Mort," epitomized local law enforcement for 35 years. At age 24, he joined the force as a patrolman. Mort turned in his badge in 1988 at age 60, holding the rank of commander of the detective bureau, and went on to serve four years as a member of the Portsmouth Police Commission. In 2002, a room in police headquarters on Junkins Avenue was named after him.

Richard Searfoss

His office was in space. Richard Searfoss grew up at Portsmouth's Pease Air Force base and graduated from Portsmouth High School. Before joining NASA in 1990, he was an Air Force pilot, test pilot, and flight instructor. During his tenure with NASA, Searfoss flew the space shuttle *Columbia* twice—as pilot in 1993, and as crew commander in 1998. He also was pilot of a 1996 mission on the shuttle *Atlantis*. (Courtesy of NASA.)

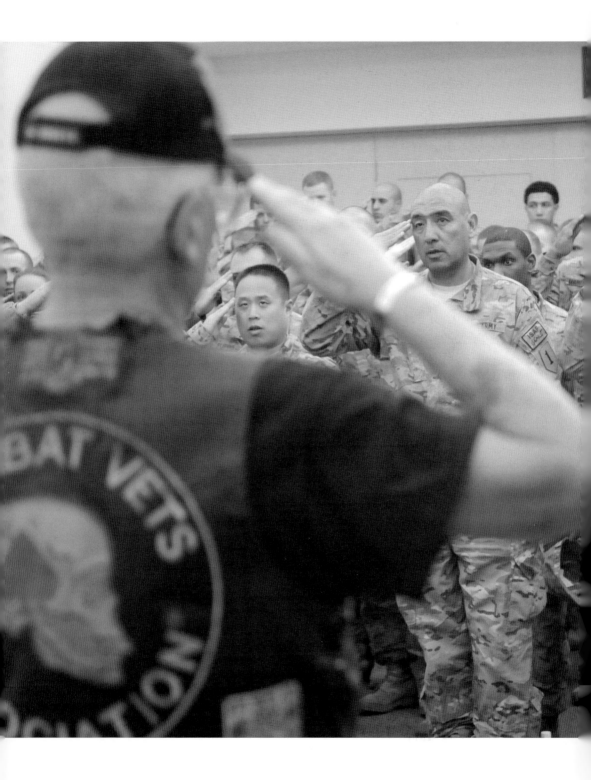

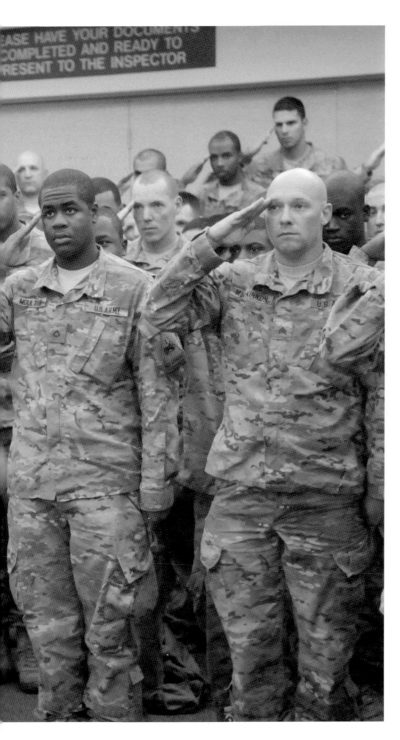

Pease Greeters

Since 2005, the Pease Greeters have attended the landings and takeoffs of all military flights at Portsmouth International Airport at Pease. "No matter day or night, if it's two in the morning or three in the morning or five at night, we're there," said Alan Weston, a founding member of the greeters.

The all-volunteer organization is made up of people young and old, both veterans and civilians. Before every flight, the greeters line the hallways of the local airport and surprise the troops with a festive greeting, not to mention food, drinks, casual conversation, and a chance to call home. In 2008, members of the Pease Greeters traveled to Washington, DC, to meet with Pres. George W. Bush.

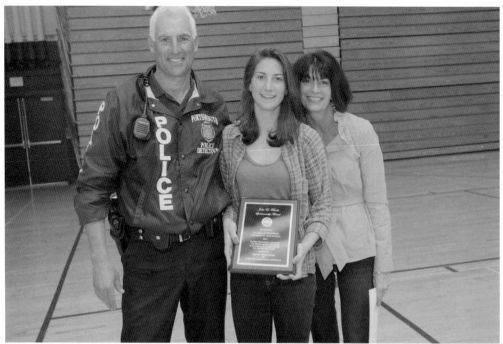

Kevin Semprini

Kevin Semprini, also called "Officer Friendly," was known both for his community relations and his work as a school resource officer for Portsmouth elementary schools, where he taught children about personal safety and drug awareness. He joined the force in 1979 and was assigned to work in the schools in 1984. In 2005, Semprini retired as a police officer but continued to serve the community.

Corey MacDonald

A Portsmouth native, MacDonald began his police career at age 14 as a police cadet. In 1999, MacDonald became a full-time officer. In the years to follow, he made his way through the ranks as a school resource officer, detective division commander, and police prosecutor. In 2012, he was named deputy police chief, making him the youngest to hold that position in the history of the Portsmouth Police Department.

Fitz John Porter

Gen. Fitz John Porter was born on August 31, 1822, in a house on Portsmouth's Livermore Street. He was most famous for his military service and for the controversy that surrounded him during the Civil War.

His family was filled with prominent naval officers, most notably his father, Capt. John Porter, a hero of the War of 1812 and commandant of Portsmouth Naval Shipyard.

By August 29, 1862, General Porter was in command of the V Corps in Virginia and was facing a difficult decision. With knowledge that Gen. James Longstreet and 30,000 Confederate troops were massed with Stonewall Jackson on the ridge above, Porter held his position and chose not to make an attack. The next day, he was ordered once again to attack, and his 5,000 troops of the V Corps became part of the slaughter of Second Manassas. Days later, Porter was arrested and court-martialed for insubordination at Second Manassas. Some at the time believed he should have been shot.

After a quarter-century, on August 6, 1886, Porter was pardoned by a military tribunal.

While he was made a scapegoat for the Union defeat, it became clear over the years that his "disobedience" and slow response to orders had, in fact, saved thousands of Union lives.

In 1894, Porter and his daughter Eva traveled from their home in New Jersey back to New England and Portsmouth.

In a letter to Gen. M.B. Franklin, which is now displayed in the Portsmouth Athenaeum, Porter wrote, "New Hampshire is the State of my birth, and my daughter, Eva, desires to go and I wish to take her there, to Exeter—my school home and to Portsmouth my birth place." Porter died May 21, 1901, and his body is buried in Brooklyn, New York.

In 1904, three years after his death, the city raised the equestrian monument to him sculpted by James Kelly. On August 6, 2011, 125 years to the day after General Porter's 1886 pardon by Pres. Grover Cleveland, the city laid a wreath at the statue in Portsmouth's Haven Park. That same year, Strawbery Banke Museum hosted an exhibit, Fitz John Porter: Civil War Hero or Coward?

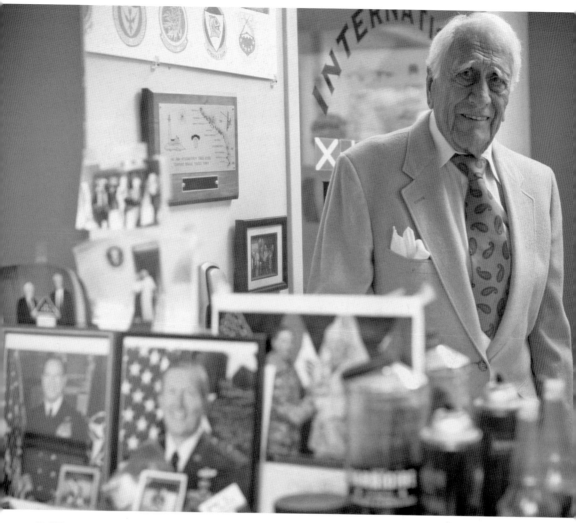

Sal Zona

It all began in January 1956 when Sal Zona first arrived at Pease Air Force Base to work as a barber. He was one of about 400 civilian employees at the time, and he ran his barbershop operation there for more than three decades. When the base closed on March 31, 1991, Zona was able to keep his barbershop, and he served the New Hampshire Air National Guard there for 15 years until he opened up his shop, International Barbershop, on Manchester Square.

In 2013, the 93-year-old barber hung up his clippers. "It's been a pleasure and an honor," Zona said during an interview with the *Portsmouth Herald*. Having spent 57 years in the barber business, most of it at Pease, Zona became known as the unofficial historian of the former air force base.

Central Veterans Council (OPPOSITE PAGE)

For years, the men and women of the Central Veterans Council have made sure that those lost while serving the country are not forgotten. In 2012, members of the Central Veterans Council of Portsmouth held a burial at sea ceremony in memory of those who made the ultimate sacrifice, marking the 38th year the event has taken place in the city. The council also sponsors the annual Memorial Day parade and other patriotic events throughout the year.

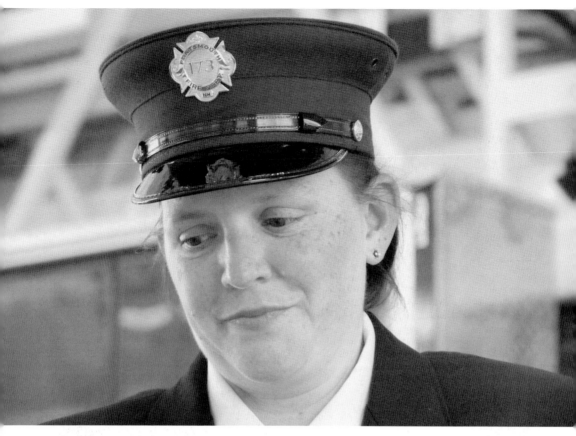

Sarah Fox

Sarah Fox was not a local resident, but her spirit touched people all over Portsmouth and beyond. She was a celebrated veteran of the Portsmouth Fire Department, joining the city as a firefighter and paramedic in October 2000.

Her strength was put to the test in 2007 after she was diagnosed with advanced cancer. Despite the sickness, Fox remained with the fire department until August 2011. During her battle, the fire department and the community rallied around her by holding numerous fundraisers intended to help the family defray the exorbitant treatment costs.

Mere months after retiring, Fox lost her four-year battle with cancer. In the end, she was remembered as a loving wife and mother and as a well-respected firefighter and paramedic.

George Pierce
George Pierce began his life in firefighting at an early age and ended his career with the Portsmouth Fire Department. He was the city's deputy fire chief and head of fire prevention and control from 1977 until his retirement in 1999. In October 2009, the training room in the city's newest fire station on Lafayette Road was dedicated in his name. He died months later at the age of 61.

Martin Cameron
A 28-year US Air Force veteran, Martin Cameron never really stopped serving his country. For years, the longtime city resident did all he could do to protect and remember local veterans. In October 2010, Cameron took it upon himself to begin caring for the monuments honoring the 26 Portsmouth residents who lost their lives serving during World War I.

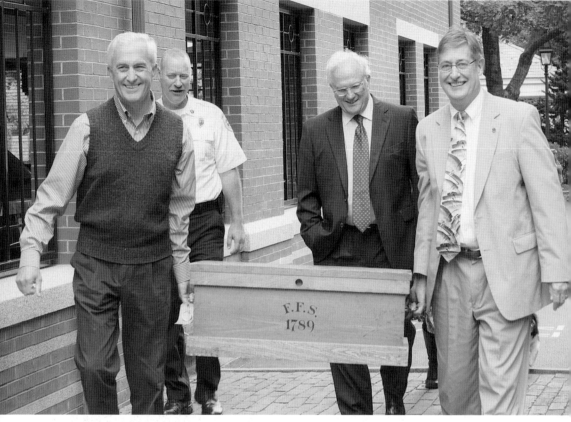

Federal Fire Society

The Federal Fire Society was formed in 1789. Members would protect one another's property in case of a fire, and each traditionally possessed two buckets, a burlap sack, a long-handled mop, and a bed wrench, among other items. These days, the fire society is more of a fraternal organization, however, members are still expected to have their own buckets.

In 2012, members of the society gathered together to officially move a 100-year-old steamer trunk containing many of the group's most historic documents to the Portsmouth Athenaeum. The trunk is filled with biographies, memorabilia, and minutes of past meetings pertaining to the history of the fire society.

Laura Kempton
She was an aspiring model whose life came to a tragic end. Kempton, a 23-year-old beauty-school student, was beaten to death in her 20 Chapel Street apartment. The sad story began on September 28, 1981, when Kempton was last seen by a friend after leaving a watering hole called the Ranger Club early that Monday morning.

At 9:00 a.m. the next day, a police officer went to Kempton's apartment to talk to her about unpaid parking tickets and found her beaten body.

After more than three decades and a list of investigators, her murder has never been solved. A $20,000 reward was offered for tips leading to an arrest and conviction for her murder. (Courtesy of Portsmouth Police Department.)

Tammy Little

A year and one month after the murder of Laura Kempton, Tammy Little was found beaten to death on October 19, 1982, in her apartment inside an antique home at 315 Maplewood Avenue.

Her last known sighting was early in the morning when she returned home from a concert in Boston and went into her apartment alone.

It would not be until days later that her mother would discover the 20-year-old's body.

Just like Kempton, the autopsy conducted by the New Hampshire medical examiner determined Little died as a result of massive head injuries. Little was also similar to Kempton in that she was an aspiring model and a student at Portsmouth Beauty School.

Her murder, which was never solved, remained one of the biggest mysteries in the city. (Courtesy of Portsmouth Police Department.)

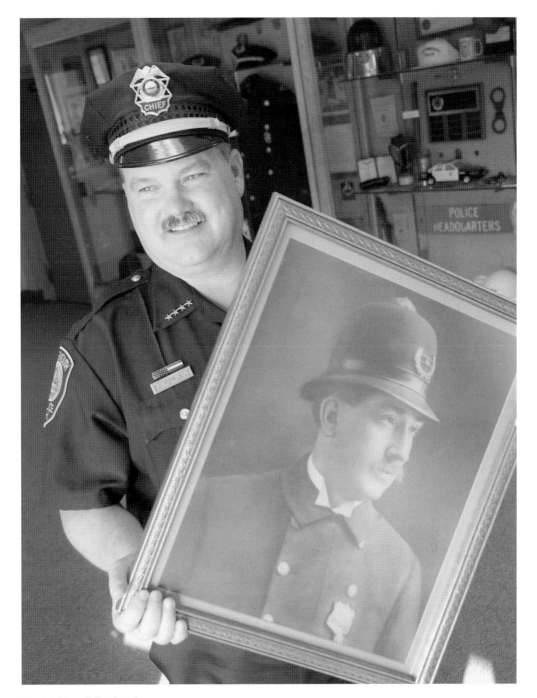

David "Lou" Ferland
David "Lou" Ferland started his career with the police department in 1983. During his career with the local police force, Ferland founded the Working Dog Foundation—the police K-9 program on the Seacoast. In 2009, he was named deputy police chief. Nine days later, after an unexpected retirement, he was promoted to chief. After three years, Ferland retired from his career in law enforcement, although he remained active in the community.

Capt. Vassilios Pamboukes

Beginning in 1989, local firefighter Vassilios Pamboukes spent nearly three decades helping protect the city. He was considered to be an ambassador to the river community and all the stakeholders involved with responding to waterfront emergencies.

When he retired from the fire department as a captain in 2008, Pamboukes continued to work, educating firefighters as part of the Maritime Incident & Resources Training Association and therefore continuing to have a lasting impact on firefighters in Portsmouth, the Seacoast, and beyond.

In addition to his firefighting duties, Pamboukes was also an active member in the community, helping organize the Greek festival put on by the St. Nicholas Greek Orthodox Church and serving as a strong advocate for public employees.

Fire Chief Christopher LeClaire
Christopher LeClaire began his career as a call firefighter in 1985 with the Hampton Fire Department and later joined the North Hampton department in 1987. There, he was promoted to the position of deputy fire chief in 1995. In 1999, LeClaire came to Portsmouth and was selected to serve as second-in-command to the fire chief. A few years later, in 2002, he became fire chief and led the department in that capacity until 2013. During his local career, LeClaire was one of 680 people in the world with the designation of chief fire officer and served as president of the New Hampshire Association of Fire Chiefs.

Mike Mone
For 14 years, Mone was a common face in the city courthouse, providing security for judges, defendants, lawyers, and regular folks. The well-known court security supervisor, who was known to be quick with a smile, retired in 2009. During his career, Mone was a longtime advocate for court security officers and a vocal opponent of the state's $65-a-day pay to most of them. He was also known to perform as a bagpiper with the police association and Coast Guard bagpipe bands, as well as with the Ancient Order of Hibernian band, which performs throughout the United States, Canada, and Ireland. Before his career at the courthouse, Mone served for a quarter-century with the US Army and the Coast Guard, where he managed three Coast Guard stations and one ship before retiring as a chief boatswain mate.

INDEX

AN IMPRINT OF ARCADIA PUBLISHING

Find more books like this at
www.legendarylocals.com

Discover more local and regional history books at
www.arcadiapublishing.com

Consistent with our mission to preserve history on a local level, this book was printed in South Carolina on American-made paper and manufactured entirely in the United States. Products carrying the accredited Forest Stewardship Council (FSC) label are printed on 100 percent FSC-certified paper.